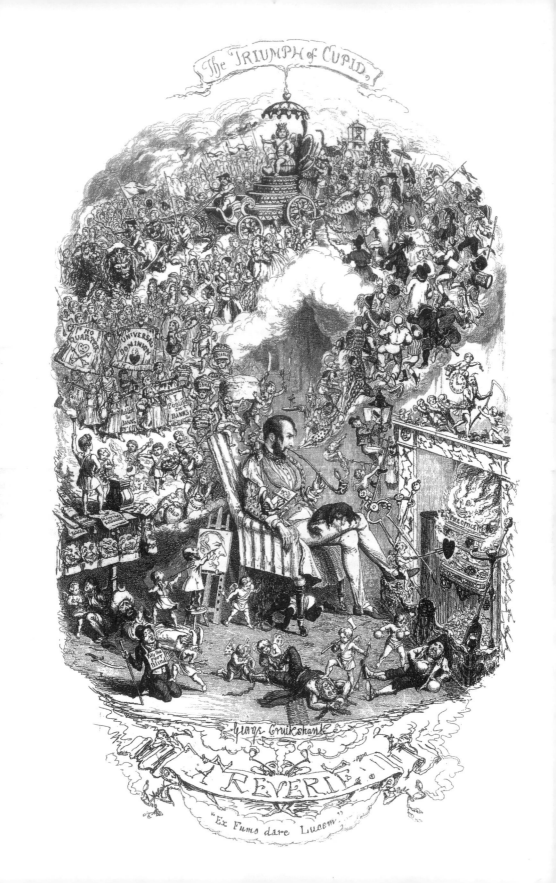

The TRIUMPH of CUPID.

Geirge Cruikshank

A REVERIE.

"Ex Fumo dare Lucem"

The Comic CRUIKSHANK

Edited by Mark Bryant
Introduction by Simon Heneage

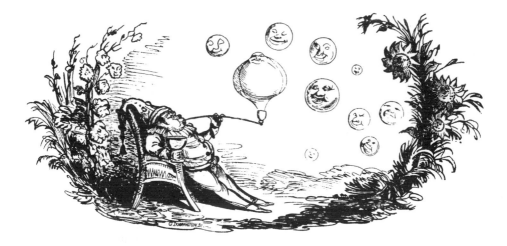

BELLEW PUBLISHING
London

First Published in Great Britain in 1992 by
Bellew Publishing Company Limited
8 Balham Hill, London SW12 9EA

ISBN 1 85725 060 5

Phototypeset by Florencetype Ltd, Kewstoke, Avon

Printed and Bound in Great Britain by
Hartnolls Limited, Bodmin, Cornwall.

CONTENTS

George Cruikshank

PREFACE

This book has been produced to mark the bicentenary of the birth of George Cruikshank (1792–1878). With Hogarth, Gillray and Rowlandson, Cruikshank is widely regarded as one of the founding fathers of British comic art, but until now surprisingly few publications have concentrated on his purely humorous work. The current volume, will, it is hoped, go some way to fill this gap.

Of course, a great many of Cruikshank's 'droll designs' could be classified as comic, regardless of content. However, the aim of the present book has been to exclude all portrait caricature, political satire and jobbing book and magazine illustration work in order to focus on his art from the standpoint of a humorous social commentator.

Due to lack of space, it has not been possible to include any comprehensive account of Cruikshank's life and other work. However, for those interested, the classic Victorian biographies by Blanchard Jerrold and William Bates, and more recent volumes by Ruari McLean, John Wardroper and others are recommended, all of which include bibliographies.

Finally, I would like to extend my thanks to all who have been involved in the preparation of this book. Especially to the Rt Hon. Kenneth Baker CH MP, who kindly agreed to write the Foreword, and to Simon Heneage for his excellent Introduction. Also to the designer, Mick Keates, to Ib Bellew, Suzie Burt and all at Bellew Publishing, and to John Wardroper whose invaluable advice and encouragement were greatly appreciated.

M.B.

Overpopulation

FOREWORD

Rt Hon. Kenneth Baker CH MP

George Cruikshank had three lives: as a cartoonist up to about 1825, then as a book illustrator, and finally as a social crusader against the evil of drink. To all of these he applied his comic genius. His cartoons, sharpened in Gillray's own studio, depicted the Prince Regent in absurd and unforgettable indulgence. Millions of readers of *Oliver Twist* will carry with them for ever the vivid and memorable pictures of Oliver asking for more, Fagin in the Death Cell and Bill Sykes and his bull-terrier.

Cruikshank's audience chuckled at his absurd exaggeration of fashionable clothes, the vain pretensions of the pompous and the popinjay, and the exaggerated calamities that affected the unwary.

Just as Hogarth depicted eighteenth-century London, so Cruikshank was the artist of Victorian London. All human life was there – the nobs, the gamblers, the potboys, the midwife, the parson, the teacher, the barber, and the Punch and Judy show. His people are spindly, bloated, billowing, howling and laughing. All his drawings are stuffed full of noisy and busy people in a great noisy and busy age. The art of the comic illustrator and the cartoonist is one of the peaks of English culture. High on that hill stands George Cruikshank.

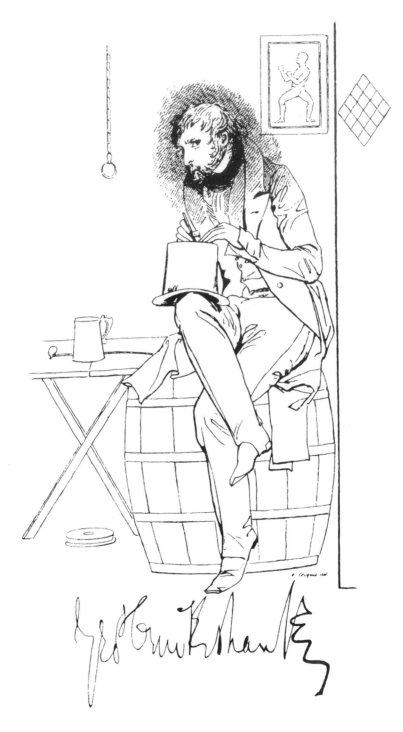

George Cruikshank by Daniel Maclise (1833)

INTRODUCTION

Simon Heneage

If anyone doubts the comic genius of George Cruikshank let him look at *The Loving Ballad of Lord Bateman*. It is one of the masterpieces of comic Victorian book illustration in company with Lear's *Book of Nonsense*, Thackeray's *Rose and the Ring*, Du Maurier's *Legend of Camelot* and Doyle's *Foreign Tour of Brown, Jones and Robinson*. Allowed a single plate from any of these books to cheer me up on the B.B.C.'s desert island it would be 'Lord Bateman, his other bride, and his favorite domestic, with all their hearts so full of glee'.

CRUIKSHANK THE MAN

L'homme c'est rien: l'oeuvre c'est tout. Whatever general truth there may be in this maxim it has little application to caricaturists who, from Hogarth in the eighteenth century to Max Beerbohm and David Low in our own, have been at pains to explain themselves. Least of all does it apply to George Cruikshank. It is quite impossible to understand and enjoy his pictorial comedy without knowing something about his personality. Like Beerbohm and Low he pressed the point by including numerous portrayals of himself in his work.

He was the strangest of men, almost to the point of dottiness. Charles Dickens, admittedly in a moment of exasperation, once wrote 'I have long believed Cruikshank to be mad.' His appearance did not help. Once he had passed through his Regency Buck phase – 'blue swallow-tail coat, a buff waistcoat, grey pantaloons and Hessian boots with tassels' (the last man in London to continue wearing such boots, so he claimed) he cultivated an old-fashioned eccentricity in dress. His hair was very remarkable. According to Dickens he had 'enormous whiskers which straggle all down his throat' and when wet 'they stick out in front of him like a partially unravelled bird's-nest'. Add to that a forelock (which in older age was held

11

in place by elastic bands to disguise a bald patch), a large and broken nose, and a notably fierce eye and one can understand why he was accused of 'frightening people from his presence' – and riposted with a brilliant self-caricature (see 'Cruikshank on Cruikshank' in this volume).

If his appearance could be startling his behaviour often matched it. As a Regency Buck, G.A. Sala said that he was looked upon as 'a bruising, gig-driving, badger-baiting, rat-matching, dog-and-duck-hunting pet of the Fancy' who as a trained pugilist and always courageous was not 'averse from using his fists in an up-and-down tussle'. In those days and for long after he was not averse from a bibulous party either. Dickens has described one such occasion: 'George Cruikshank was perfectly wild at the reunion; and after singing all manner of maniac songs, wound up the entertainment by coming home (six miles) in a little open phaeton of mine, *on his head* – to the mingled delight and indignation of the metropolitan police.' After a similar spree his friends left him trying to climb up a lamp-post. It was the demon drink and at one stage, according to Henry Vizetelly, he was badly affected: 'Somewhere in the 'forties before the publication of his famous "Bottle" [eight designs on the evils of alcohol], drink had so far got the mastery over Cruikshank that he was pretty constantly in police custody during the small hours of the morning.' That was a bad patch. Most of the time it was social drinking, but he knew what he was drawing in the illustrations to *The Bachelor's Own Book*, which show Mr. Lambkin in 'convivial' mood.

As to his opinions, to quote Dickens again 'he makes the strangest remarks that the mind of man can conceive, without any intention of being funny, but rather meaning to be philosophical'. To judge by his work his opinions were changeable, implying that they were intuitive rather than reasoned or that he was content to draw to order. At one moment he was representing George IV as a drunken debauchee, the next the king appears as Coriolanus at his most noble. A print condemning government brutality at Peterloo is followed by another denouncing radical agitators. Sympathy for the condition of the poor is balanced by ridicule for their pretentious aspirations. Even on Temperance, his great Cause, he was inconsistent until 1847 when he took the pledge. Even afterwards, possibly, if there is significance in the provision of his will in which he left to Mrs. Archibold – the lady for whom he maintained a separate establishment – his 'wines' amongst other effects. This reminds one of the story about the bishop who was asked by one of his clergy if he would 'partake of some liquid refreshment, perhaps a glass of sherry?' 'No,' replied the bishop, 'and for two reasons. The first is that I am President of the National Temperance Society. The second is that I have just had one.'

All in all George Cruikshank was a 'character', an 'original', or as he was often called 'inimitable'. He shifted his ground like Cobbett; he outgrew his age like Palmerston; like both of them he was brave, energetic, combative and transparent. It was this last quality above all which endeared him to his friends. The *Punch* obituarist put it generously and well:

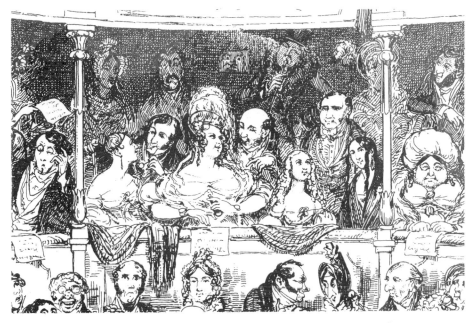

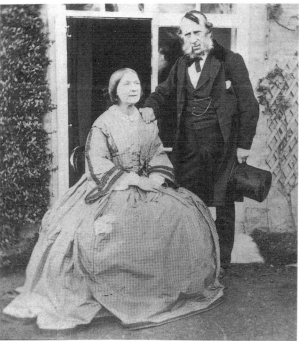

(*Above*) Detail from 'Pit, Boxes & Gallery' from *My Sketch Book* (1834–5). Cruikshank himself can be seen in the centre box, second from right, talking to a woman, probably his wife. (*Right*) George and Mary Cruikshank in later life. (Photo courtesy of the National Portrait Gallery, London.)

His nature had something childlike in its transparency. You saw through him completely. There was neither wish nor effort to disguise his self-complacency, his high appreciation of himself, his delight in the appreciation of others, any more than there was to make himself out better or cleverer or more unselfish than his neighbours . . .

Honesty was the quality he professed to value most and the quality that Thackeray most prized in his work – 'earnestness and good faith' – and in line with the precepts of Hogarth and Ruskin the honesty had to have a moral application. In the 1860s he declared that his occupation was 'Painting and Drawing to prevent Evil and to try to do Good.' It was a not uncommon Victorian aspiration and can be compared with the motto that G.F. Watts inscribed over his studio door, 'The Utmost for the Highest'. For the first forty years or so his performance was fitful, his honesty conflicting with necessity or with the strong streak of theatricality in his nature – the stage had been his first choice of profession. For the last thirty it was admirably sustained and people assumed (wrongly) that the humorous Cruikshank lay buried under a mound of teetotal propaganda. He was indeed a mass of contradictions but a sizeable amount of his comic art was inspired, as he said, by the impulse to 'try to do good'.

EARLY WORK

'There must be no smiling with Cruikshank. A man who does not laugh outright is a dullard, and has no heart.' Thackeray's verdict can be compared with Hazlitt's remark that Hogarth's pictures 'made you burst your sides with laughing' and both serve to emphasize the gap between the nineteenth-century appreciation of humour and our own. But whilst we may no longer guffaw there is, *pace* Thackeray, much cause for smiling in Cruikshank's work.

It started rudely. His first major challenge came in 1811, when, at the age of nineteen, he became the resident caricaturist for *The Scourge; or Monthly Expositor of Imposture and Folly*. From the start he responded with all the required gusto and vulgarity. The next year he produced seven prints jeering at the *amours* of the Regent and his brothers which went close to the limits of bad taste and inspired the *Morning Post* to call for a ban on all such caricatures. All Cruikshank was doing, however, was to follow Gillray, the master and mentor he so much admired. In fact he was more playful than his master; less venom meant less impact but it was none the less a remarkable debut.

He continued the Gillrayesque approach in his political caricatures and in his illustrations to the *Life of Napoleon* (1815), in which he revealed a talent for broad farce. By the end of the decade, when he embarked on a series of illustrations to the polemical pamphlets of William Hone, he had overtaken Rowlandson and Williams as the leading caricaturist of the day.

Like the other caricaturists he combined social comment with political satire and in the former he developed a speciality – Fashion. Between 1816

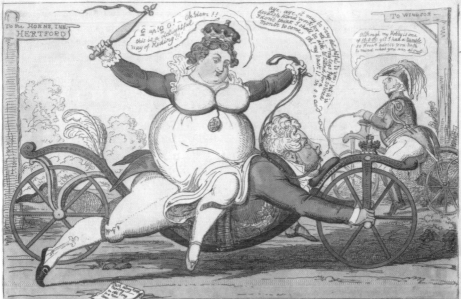

Lady Hertford astride the Prince Regent (later George IV) as a
hobby-horse whilst the Duke of York looks on (1819).

and 1829 he produced a series of satires on fashions and the Dandies –
mostly entitled 'Monstrosities' (see 'The Glass of Fashion' and colour
section) – that have never been excelled. In the first, 'Monstrosities of
1816', there was a clear debt to Gillray (and the French prints that Gillray
had copied); the figures are a little stiff and the composition is not exciting.
'Monstrosities of 1818' is a clear improvement, 'Monstrosities of 1821' has
some delicious touches of humour in the expressions and 'Monstrosities of
1822' is superb, only equalled by 'Humming Birds – or a Dandy Trio'
(1819), 'Beauties of Brighton' (1826) after a design by Crowquill, and
'Monstrosities of 1825–26'. In these prints exaggerated elegance is carried
to a wonderful pitch of absurdity. He wasn't, of course, the only artist to
mock the Dandies; just as Darly and others had mocked the 'Macaroni' so
Williams, Cruikshank's brother Robert and the two Heaths mocked the
Dandies, and Du Maurier was to mock the 'Swells'. But for me only
Anton's 'Spivs' have the same sartorial appeal.

Cruikshank didn't much care for the Dandies – something of the age-old
contempt of the 'hearties' for the 'arties' – and he didn't much care for the
French either, doubtless subscribing to the sentiment (was it Wellington's?)
that 'the English always did and always will and always *should* detest the
French'. Yet the caricatures of the early 1820s, 'Anglo-Gallic Salutations'
and 'The Advantages of Travel' are not only good-humoured but show his
own countrymen in no less ridiculous a light than the French.

15

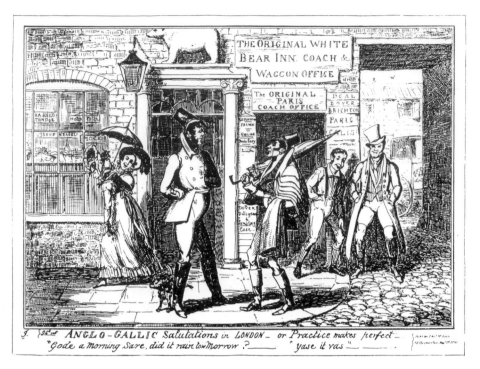

'Anglo-Gallic Salutations in London – or Practice Makes
Perfect' (1835). One of a series of illustrations depicting the
problems of speaking a foreign language, both in Britain
and overseas.

The distinction between social and political caricatures is not always easy
to make. 'Inconveniences of a Crowded Drawing-Room' (1818), perhaps
Cruikshank's best-known print (see colour section), is at one and the same
time a satire on the crowded conditions at royal receptions, or 'Drawing-
Rooms', and a celebration of comic accidents. It demonstrates all the most
attractive elements of his art – crowded but well-grouped composition,
lively drawing, dramatic gestures, droll expressions verging on the grotes-
que. It also demonstrates how well his talents were suited to the medium of
etching.

The plates in *Life in London* (1821), to which he contributed a share of
the illustrations, and *Life in Paris* (1822), all his own work, are aquatints,
and those in *Points of Humour* (1824) are wood-engravings. Successful
though these were, they do not show Cruikshank's humorous invention to
full advantage and for that we have to wait for the series of albums which
starts with *Phrenological Illustrations* (1826) and is continued with
Illustrations of Time (1827), *Scraps and Sketches* (1828–32) and *My Sketch
Book* (1833–6) in which he reverted to etchings. Similar albums of work by
Alken, H. Heath, Seymour and Crowquill had been published around the
same time; the difference was that Cruikshank, in order to keep editorial

control, dispensed with a publisher and undertook the job himself. So in these albums in which the drawings had been chosen by himself, executed in his favourite medium and made in the prime of life, we can expect to find the essence of Cruikshank's humour.

What are its characteristics? I think we can consider all four books together for, apart from the fact that the first two have a theme and the last lives up to its title by including a large number of marginal sketches, there are no substantial differences. The first characteristic that strikes one, remembering the rudeness in *The Scourge*, many of the political prints, and Hone's pamphlets, is mildness. The vast majority of the seventy-four plates are illustrations of puns, desperately feeble by our standards but par for the course in those days, (the appetite for the works of Tom Hood standing as an example). The second is popularity, in the sense of depicting the customs and attitudes of the people. There is the odd illustration of 'fashionables' such as 'A Scene in Kensington Gardens' and the two caricatures of high-life in Cheltenham, but most of the jokes and studies are of low-life. Lastly comes the grotesque. Whether one thinks of the anthropomorphic pages like 'Odd Fish' and 'Zoological Sketches' (see 'Zoological Fancies') or simply the portrayal of human physiognomy, Cruikshank's talent for grotesque humour is abundantly evident. The exceptions to the mild facetiousness, the punning and the whimsicality (but not the grotesque) come in four powerful plates: 'The Gin Shop, 'The Pillars of a Gin Shop', 'The Gin Juggarnath' and 'The Fiend's Frying Pan'. Whatever humour may be found in these sermons is too harsh and bitter to merit attention in *The Comic Cruikshank*.

THE COMIC ALMANACK
AND LATER WORK

The Comic Almanack (1835–53), which contained monthly etchings, gave Cruikshank as much unfettered opportunity to express his humour and his opinions as the albums, and there is progress in a number of directions. The compositions tend to be more crowded and more boisterous, the characterization more acute, the drawing more precise. The settings are now more middle- than lower-class. Quite new elements of fantasy are introduced in 'A Swallow at Christmas' (December 1841) and the science-fiction plates, 'Science under Divers Forms' and 'Air-um-Scare-um Travelling' (July and August 1843). Anthropomorphism accelerates towards the end; in the *Almanack* for 1851 half the plates are of this nature. Generally speaking, there is little concern for social issues, apart from drink on which the artist's standpoint, until 1848, seems to be ambivalent. As a whole, the *Comic Almanack*s parade the full range of Cruikshank's mature comic talents, playful without a trace of sentimentality, tinged with the grotesque, so that smiling is often accompanied by a sense of unease.

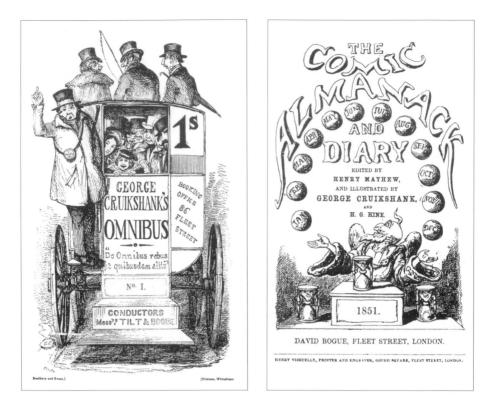

Cover of *George Cruikshank's Omnibus* (1841–2) and title page
of the 1851 issue of *The Comic Almanack* (1835–53).

I have said before that *The Loving Ballad of Lord Bateman* (1839) is in
my view a comic classic as funny now as when it was conceived. It is a
mystery to me why Cruikshank did not attempt more work in this vein,
absurdity expressed in outline etching. Equally mysterious is the relative
lack of acclaim it has attracted from critics despite its popularity with the
public. Blanchard Jerrold in the last century called the illustrations 'exqui-
site foolery' but Michael Wynn Jones in his perceptive biography of 1978
couldn't rise higher than 'interesting but uncharacteristic' while John
Buchanan-Brown in *The Book Illustrations of George Cruikshank* (1980)
mentions them without comment. Dickens got it right when he wrote to the
artist 'you never did anything like these etchings – never'. From the
opening picture of Lord Bateman tip-toeing along the seashore to the close,
when he dances off stage with the Turk's daughter and 'the proud young
porter', one floats along on a gentle tide of hilarity.

Such rhapsodies don't suit *The Bachelor's Own Book* (1844) subtitled
*The Progress of Mr. Lambkin (Gent.) in the Pursuit of Pleasure and
Amusement. . .* This was an attempt by Cruikshank to emulate one of
Hogarth's 'Progresses' or as he called them, 'Modern Moral Pictures', like
The Rake's Progress, in which he satirized the follies and vices of his age.

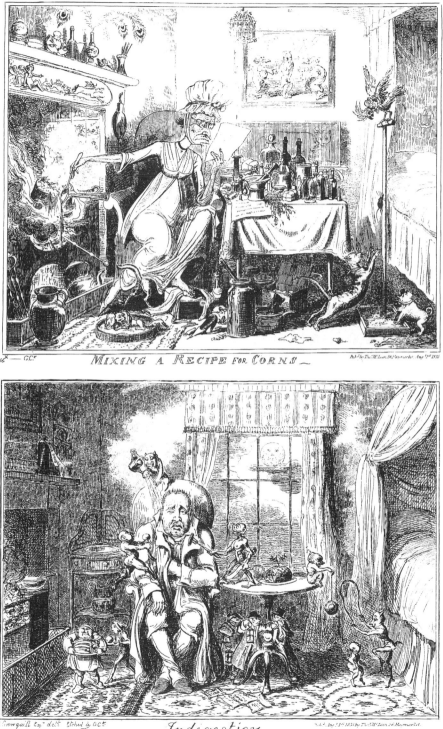

MIXING A RECIPE FOR CORNS

Indigestion

(*Left*) Cover design for *George Cruikshank's Table Book* (1845).
(*Bottom left*) The letter 'W' from *A Comic Alphabet* (1836).
(*Bottom right*) Letter by Cruikshank to Lamon Blanchard, his friend and editor of the *Omnibus*, signed with a self-caricature.

W
Waistcoat

There are echoes of Hogarth in one or two plates (and of other artists; Mr. Lambkin preening himself in the mirror is similar to a Dandy caricature by Williams), but the moral impact of the book must have been negligible as Mr. Lambkin is nothing but a buffoon and the story ends comfortingly. It is too genial and too long, a burlesque rather than a satire, yet some of the individual illustrations are most amusing, especially those in which Mr. Lambkin has taken a drop too much.

When Cruikshank finally came off the fence about drink in 1848 and published that harrowing indictment 'The Bottle', he had not finished with comic work. That same year appeared *The Greatest Plague in Life or the Adventures of a Lady in Search of a Good Servant* by the brothers Mayhew, for which Cruikshank provided sprightly illustrations without the condescension likely to have come from one of the *Punch* artists. Previously there had been some arresting comic work in the *Omnibus* (1841–2) and the *Table Book* (1845) and more was to come in *The Toothache* (1850) and *The Life of Sir John Falstaff* (1858), but by this time Cruikshank was out of fashion as a humorous artist and deeply absorbed in a crusade for Total Abstinence.

CRUIKSHANK
AND THE VICTORIANS

Why did Cruikshank's work go out of fashion in the mid-nineteenth century and what are the elements in his humorous art which appeal to us today?

The easiest way to answer the first question is to compare Cruikshank with his successor as the nation's most popular humorous artist, John Leech. However inconsistent Cruikshank was in his private life, he changed little as an artist, once he had shaken off the influence of Gillray in the 1820s. His forte was the small-scale vignette etching, intricate and delicate, sometimes decorative, never beautiful. The mood of these etchings was saturnine rather than gay, the subject matter was inclined to be coarse. In fact Cruikshank often seemed to revel in ugliness. The Victorians, under the influence of Thackeray and others, wanted to repudiate the coarse past; they wanted beauty, restraint and benevolence in their humorous art. Whereas Cruikshank gave them brawny viragos, frequently coming to blows, Leech gave them damsels, polite and enchantingly pretty. Thackeray praised Cruikshank for his realism and honesty; he praised Leech for his 'wholesomeness' and 'goodness'. And whereas Dickens applauded Leech's art as 'always the drawings of a gentleman', Cruikshank was criticized because the figures in his genteel comedies 'lacked breeding'. It wasn't the actual humour itself that offended the Victorians – their appetite for punning was no less large and undiscriminating than Cruikshank's – it was just that the settings for puns had to be purged of exaggeration and any trace of Regency grossness. Cruikshank, by 1850, was too old, too conservative and too proud to adapt to the new climate.

He had earlier said of Leech's work: 'Yes, yes, very clever. The new school, you see. Public always taken with novelty' – but he wasn't going to change himself.

Nowadays our respect for Victorian values is almost invisible and most sentimental Victorian humour tends to make us wince. We warm more to the Regency period because, by contrast, the humour had few inhibitions. Our present cartoonists have also rediscovered the comic potential of the grotesque. 'Larry' and Bill Tidy love ugliness, as do Honeysett and McLachlan, who invest it with menace. Ronald Searle, the doyen of British cartoonists, has declared his reverence for Cruikshank and struck a medal in his honour as – with Caracci, Ghezzi, Hogarth, Gillray and Rowlandson – one of the 'Six Fathers of Caricature'. The sort of black humour which is a feature of Cruikshank's art has a following which will continue so long as the grotesque, which has been defined as 'the estranged world', is preferred as a basis for cartooning to anything which smacks of sentimentality. What Baudelaire called 'his inexhaustible abundance in the grotesque' is by no means Cruikshank's only contribution to comic art but, compared to the work of his immediate successors, it has given him the latest, perhaps the last laugh.

Simon Heneage is Chairman of the Cartoon Art Trust and a former Sotheby's consultant with a special interest in Cruikshank and his contemporaries.

The Toothache

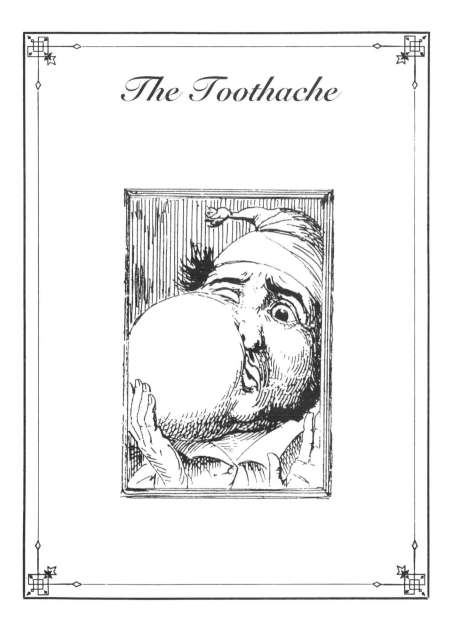

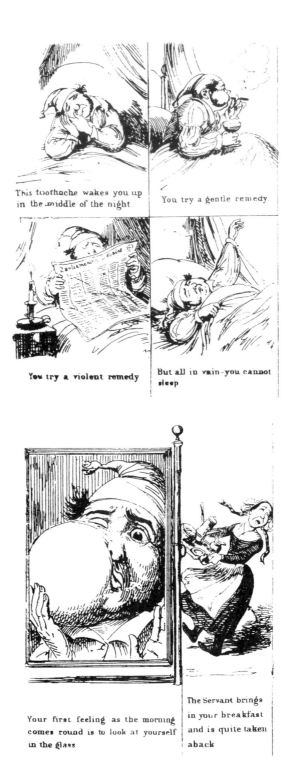

This toothache wakes you up in the middle of the night.

You try a gentle remedy.

You try a violent remedy

But all in vain-you cannot sleep

Your first feeling as the morning comes round is to look at yourself in the glass

The Servant brings in your breakfast and is quite taken aback

24

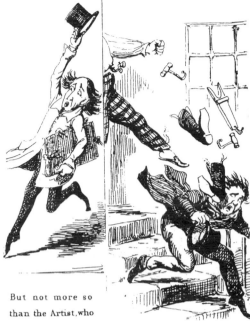

But not more so than the Artist, who comes to take your portrait.

Your Boot-maker presents his 'little bill' for the pair of tight boots—You give him 'something on account.'

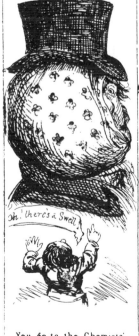

You go to the Chemists'.

And purchase some creosote.

But it does not give you much relief.

After trying the 240 Infallible cures for
the Toothache,' you go to bed again, and
enjoy a few moments of quiet rest.

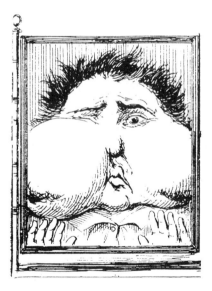

But the evening's amusement
scarcely bears the morning's
reflection. Every attempt to
shave is hopeless upon the face
of it.

You console yourself
with a poultice.

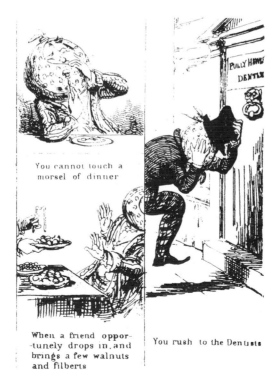

You cannot touch a
morsel of dinner

When a friend oppor-
-tunely drops in, and
brings a few walnuts
and filberts

You rush to the Dentist's

27

But no sooner is
the door opened
than the toothache
has quite left you,
and

You cannot sufficiently
express your unbounded joy

But, in the middle of
the night, you are ar-
roused once more to
the painful nature of
your position

And strongly wish
that the Dentist had
just looked at your
tooth.

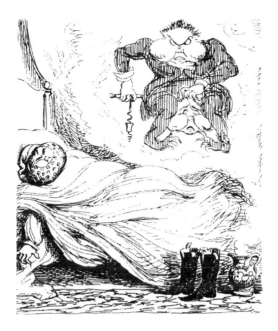

At last, just as your boots and hot wa-
-ter are brought in, you fall asleep
and have the most delicious dreams.

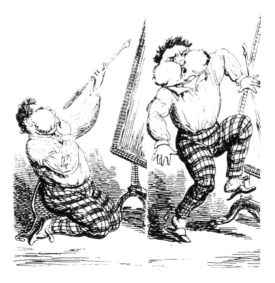

The first thing in the
morning you try another
"infallible remedy."

But, instead of des-
-troying the nerve, you
only succeed in bur
-ning your fingers.

Having heard of some most wonderful cases of tooth-ache being effectually cured by Steam, you inhale it for half an hour.

But, stupidly pausing to take breath, you are completely overwhelmed by the consequences

Being told by an old woman that filling your mouth with cold water and sitting on the hob till it boils, is a certain cure, you take your seat (and the oaths accordingly) but want the firmness and coolness to persevere

You rush to the Dentist's once more and plunge head-long in

But a scream in the next room
nearly lifts you off your feet. You
determine upon going home

When a strong feeling of
shame pulls you back, and

You are requested to
sit down for a few
minutes, and make
yourself comfortable

You are asked to be very
particular in pointing
out the Tooth, as yester-
day the Dentist pulled out
a wrong one by mistake

31

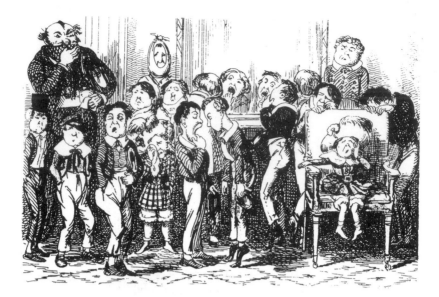

But the Servant coming in to announce that D^r Tobias Birch has called with his young pupils to pass their half-yearly dental examination. you are strongly requested "to be a man, and please make haste."

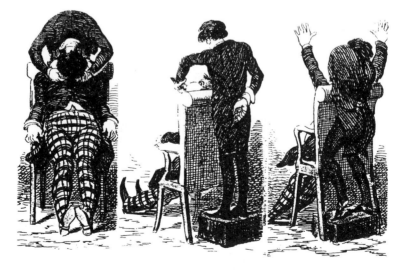

You resign yourself boldly to your fate

Once in the hands of the Dentist, the time seems interminable

This is the first quarter of an hour!

32

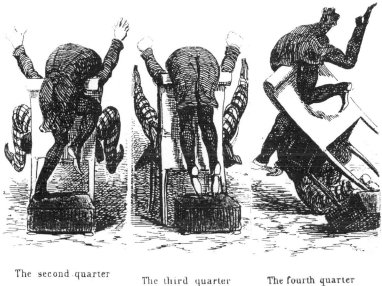

The second quarter
of an hour!!

The third quarter
of an hour!!!

The fourth quarter
of an hour!!!!

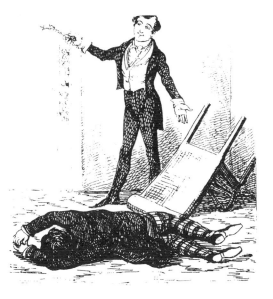

But, AT LAST IT IS OUT!

When you are as-
tonished to find
that the operation
has lasted less
than a minute

You bless the Dentist

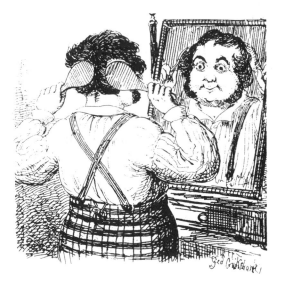

And you go home, dine, sleep well, and the
next morning are delighted to find that
you are none the worse for the Toothache.

34

'Mrs. Gamp and the Great George'

(Charles Dickens, 1847)

'I do assure you, Mrs. Harris, when I stood in the railways office that morning, with my bundle on my arm, and one patten in my hand, you might have knocked me down with a feather, far less porkmangers which was a lumping against me, continual and sewere all round. I was drove about like a brute animal and almost worritted into fits, when a gentleman with a large shirt-collar, and a hook nose, and a eye like one of Mr. Sweedlepipes's hawks, and long locks of hair, and wiskers that I wouldn't have no lady as I was engaged to meet suddenly a turning round a corner, for any sum of money you could offer me, says, laughing, "Halloa, Mrs. Gamp, what are *you* up to?" I didn't know him from a man (except by his clothes); but I says faintly, "If you're a Christian man, show me where to get a second-cladge ticket for Manjester, and have me put in a carriage, or I shall drop." Which he kindly did, in a cheerful kind of a way, skipping about in the strangest manner as ever I see, making all kinds of actions, and looking and vinking at me from under the brim of his hat (which was a good deal turned up) to that extent, that I should have thought he meant something, but for being so flurried as not to have no thoughts at all until I was put in a carriage along with an individge – the politest as ever I see – in a shepherd's plaid suit with a long gold watch-guard hanging round his neck, and his hand a trembling through nervousness worse than a aspian leaf.' Presently they fell into conversation.

' "P'raps," he says, "if you're not of the party, you don't know who it was that assisted you into this carriage!"

' "No, sir," I says, "I don't indeed."

' "Why, ma'am," he says, a-wisperin, "that was George, ma'am."

' "What George, sir? I don't know no George," says I.

' "The great George, ma'am," says he. "The Crookshanks."

' "If you'll believe me, Mrs. Harris, I turns my head, and see the wery man a-making pictures of me on his thumb nail, at the winder! While another of 'em – a tall, slim, melancolly gent, with dark hair, and a bage

vice – looks over his shoulder, with his head o' one side as if he understood the subject, and cooly says, 'I've draw'd her several times – in *Punch*,' he says too! The owdacious wretch!" '

[The melancholy gent with the 'bage vice' was Leech.]

The Venerable George

The Comic Almanack

JANUARY

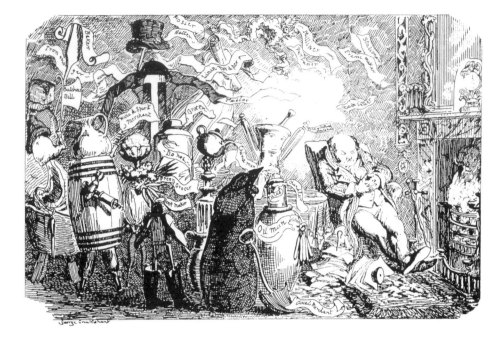

CHRISTMAS BILLS

Merry Christmas and happy New Year!
 Here's a bundle of 'little accounts':
And their bearers left word they'd be glad
 If you'd settle their little amounts.
They've all got 'large sums' to 'make up',
 And cannot wait longer, they swear:
So I wish you the joys of the season –
 Merry Christmas and happy New Year!

FEBRUARY

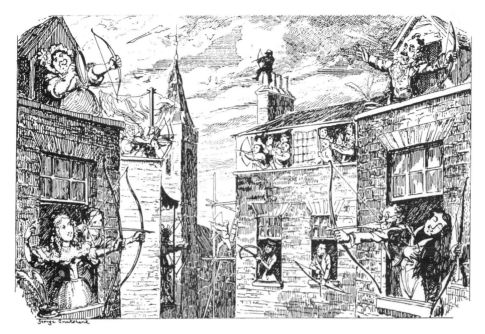

St. Valentine's Day

Birds, this month, do bill and coo;
Do the like, and you may rue.
Courting is a pretty pleasure;
Wed in haste, repent at leisure.

The Better half —

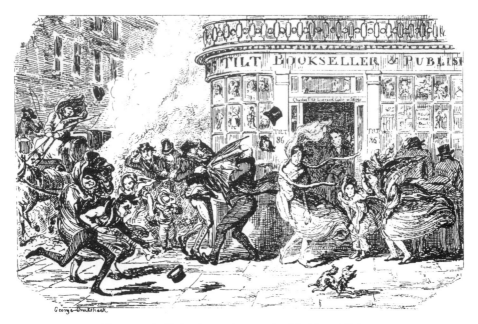

(George Cruikshank can be seen beside his publisher,
Tilt, in the doorway [Ed.])

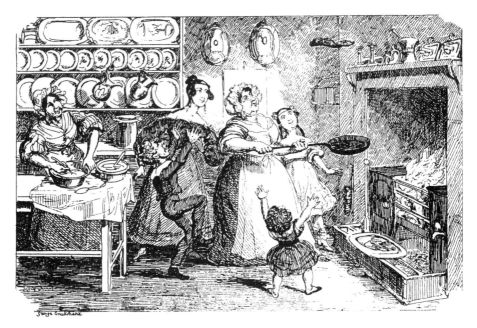

APRIL

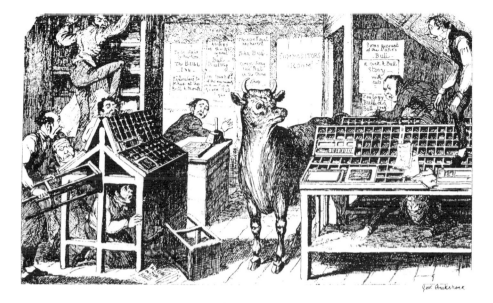

Taurus

BULL IN THE PRINTING OFFICE

by W. Wordsworth, Poet Laureate

Oh! Bull, strong labourer, much enduring beast,
 That with broad back, and sinewy shoulder strung,
 Draggest the heavy wain of taxes, flung
In growing heap, from thy poor brethren fleeced.

Hadst thou a literary sense of shame,
 How wouldst thou crush, and toss, and rend, and gore
 The printing press, and hands that work therefore,
For the sad trash that issues from the same.

If they would print no other works than mine,
 The task were nobler; but alas, in vain,
 Of audience few and *un*fit I complain,
Bull won't believe in Southey's verse and mine.

Arouse thee, John, involve in general doom
All who bid Wordsworth rise for Byron to make room.

MAY

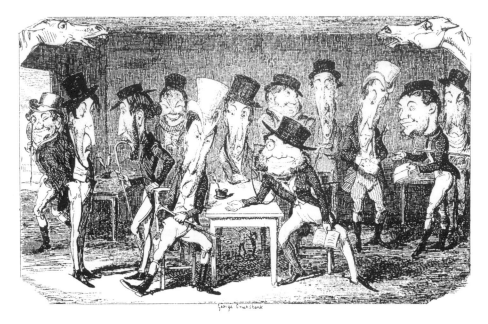

Settling for the Derby – Long Odds and Long Faces

SETTLING DAY AT 'THE CORNER'

'AS I WAS GOING TO (THE) DERBY,
ALL ON, &C.' – OLD SONG.

I wish I'd never bet;
I wish I'd never seen a horse or colt;
I wish I'd never join'd that jockeying set.
I wish I'd stopped away
From Epsom on the Derby Day –
And all such places!
I wish I'd kept at home,
And never shown my person at a Hippodrome.
I wish, instead of going like a dolt
To those horse races
I'd gone to Cowes Regatta!

We've all our ups and downs, I know,
Both great and small;
But, oh!
Those Epsom Downs are worst of all.

[. . .]

I've burnt my 'books'; no horse again I'll back
 (Racer or hack):
No more I'll hedge: and by the Grecian gods,
 I'll not stand on the long odds.
With tens, and fives, and fours, and threes to one
I've done. I've done with saying 'Done, done, done!'
My means no more I'll stake upon a Derby Day:
 It's my last lay.

 From this day forth for evermore,
Though I should live to four – or forty score,
 I'll never lay another shilling –
 If I do I'm a villain –
 (Be this the moral of my tale),
Though you should make me the most tempting offer –
 Golconda to an empty coffer –
A thousand sterling to a pint of ale –
 You shan't prevail.
 No matter what the sum
 I won't.

 * * * * * *

 Come,
I'll bet you half-a-crown I don't!

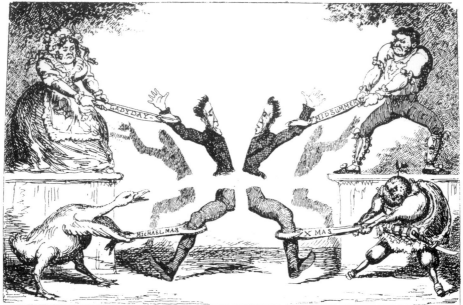

Quarter Day

Cancer

JULY

Dog-Days

Leo – Androcles and the Lion

AUGUST

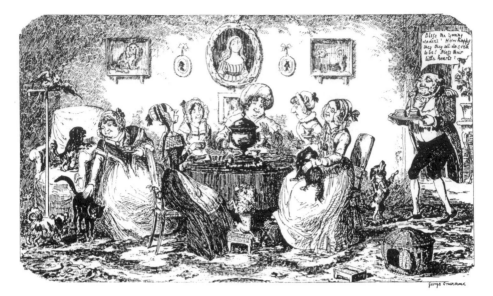

Virgo

VIRGO – THE OLD MAID

[Scene – A Tea Table]

You like it weak, Miss Patience Crab – the same, just as the last?
(As I was saying, all those Smiths are living much too fast.)
One lump of sugar more, my dear? Thank you, that's just the thing.
(No income can support those trips to London every spring –)
Another crumpet, dear Miss Quince – nay, just one tiny bit?
(The set the girls made at Sir John did not turn out a hit.)
Poor Carlo don't seem very well; I think he has caught cold –
(The eldest girl is passable, I own, but much too bold.)
The poor dear darling dog is anything but strong.
(Depend upon it, we shall hear of something going wrong.)
Another cup, love? Sugar? Milk? I hope you like your tea?
(I don't mean to insinuate – no matter – we shall see.)
Now let me recommend the cake; you'll find it very nice.
(I really hope that those poor Smiths will take some friend's advice.)

*[Cats and dogs begin to fight – parrot screams – confusion.
The conversation is broken up.]*

SEPTEMBER

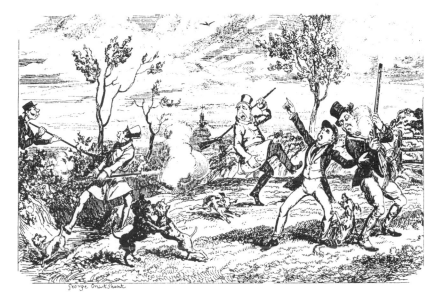

George Cruikshank

Cockney Sportsmen

'. . . Left the Dog and Partridge and took a north-easterly direction, so as to have the adwantage of the vind on our backs. Dogs getting very riotous, and refusing to answer to Figgins's vhistle, vich had unfortunately got a pea in it – Getting over an edge into a field, Hicks's gun haccidentally hexploded, and shot Wiggins behind; and my gun going off hunexpectedly at the same moment singed avay von of my viskers and blinded von of my heyes – Carried Wiggins back to the inn: dressed his wound, and rubbed my heye with cherry brandy and my visker with bear's grease. – Sent poor W. home by a short stage, and resumed our sport. – Heard some pheasants crowing by the side of a plantation. Resolved to stop their cockadoodledooing, so set off at a jog-trot. Passing thro' a field of bone manure, the dogs unfortunately set to work upon the bones, and we couldn't get 'em to go a step further at no price. Got vithin gun-shot of two of the birds, vich Higgins said they vos two game cocks: but Hicks, who had often been to Vestminster Pit, said no sitch thing; as game cocks had got short square tails, and smooth necks, and long military spurs; and these had got long curly tails, and necks all over hair, and scarce any spurs at all. Shot at 'em as pheasants, and believe we killed 'em both; but hearing some orrid screams come out of the plantation immediately hafter, ve all took to our 'eels and ran avay vithout

stopping to pick either of 'em up. – After running about two miles, Hicks called out to stop, as he had hobserved a covey of wild ducks feeding on a pond by the road side. Got behind a haystack and shot at the ducks, vich svam avay hunder the trees. Figgins wolunteered to scramble down the bank, and hook out the dead uns vith the but-hend of his gun. Unfortunately bank failed, and poor F. tumbled up to his neck in the pit. Made a rope of our pocket handkerchiefs, got it round his neck, and dragged him to the Dog and Doublet vere ve had him put to bed, and dried. Werry sleepy with the hair and hexercise, so after dinner took a nap a-piece. – Woke by the landlord coming in to know if ve vos the gentlemen as had shot the hunfortunate nursemaid and child in Mr. Smithville's plantation. Swore ve knew nothing about it, and vile the landlord vas gone to deliver our message, got out of the back vindow, and ran avay across the fields.'

1st of September

OCTOBER

Scorpio

SCORPIO – THE SLANDERER

Well, I really can't see how a laugh can be got
Out of slander, and scorpions, and lies, and what not;
If out of such subjects grow matter of mirth,
'Tis for gentry in black who live lower than earth.

And I know for my own part I've reason to grieve
That young women anonymous letters believe;
What a Scorpion was he who wrote my Mary Anne
That I was a very 'irregular man'!

Oh! cruel George Cruikshank, how could you invent
Such a horrible picture with comic intent?
I hope that if ever you've your Mary Anne,
You'll be called, as I was, an 'irregular man'.

NOVEMBER

The Gunpowder Plot or Guys in Council

GUNPOWDER PLOT

'Tis good to remember
The Fifth of November,
Gunpowder, treason, and plot;
There's abundance of reason
To think of the treason,
Then why should it e'er be forgot?

Our sympathies thrive
By keeping alive
Such sweet little hatreds as these;
And folks love each other
As dear as a brother,
Whose throat they are ready to squeeze.

I delight in the joys
Of the vagabond boys,
When they're burning Guy Vaux and the Pope;
It the flame keeps alive,
It makes bigotry thrive,
And gives it abundance of scope.

'Tis a beautiful truth
For the minds of our youth,
And will make 'em all Christians indeed;
For the Church and the State
Thus to teach 'em to hate
All those of a different creed.

DECEMBER

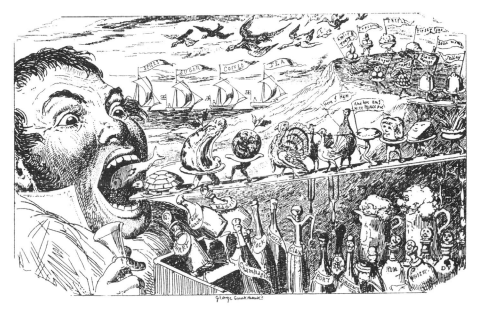

A Swallow at Christmas (*Rara Avis in Terris*)

CHRISTMAS COMES
BUT ONCE A YEAR

Christmas comes but once a year;
 By Jove! it hadn't need come more,
Unless it wants to ruin me
 Outright, and turn me out of door!
That horrid fit of gout, brought on
 By neighbour Guzzle's Christmas cheer
I thought it would have kill'd me quite;
 But Christmas comes but once a year.

'On the Genius of George Cruikshank'

(William Makepeace Thackeray,
The Westminster Review, August 1840)

Accusations of ingratitude, and just accusations no doubt, are made against every inhabitant of this wicked world, and the fact is, that a man who is ceaselessly engaged in its trouble and turmoil, borne hither and thither upon the fierce waves of the crowd, [. . .] has hardly time to think of anything but himself, and, as in a sinking ship, must make his own rush for the boats, and fight, struggle and trample for safety. In the midst of such a combat as this, the 'ingenious arts, which prevent the ferocity of the manners, and act upon them as an emollient' (as the philosophic bard remarks in the Latin Grammar) are likely to be jostled to death, and then forgotten. [. . .] Happy he whose fortune has placed him where there is calm and plenty, and who has the wisdom not to give up his quiet in quest of visionary gain.

Here is, no doubt, the reason why a man, after the period of his boyhood, or first youth, makes so few friends. Want and ambition (new acquaintances which are introduced to him along with his beard) thrust away all other society from him. [. . .]

The reader who has seen the name affixed to the head of this article did scarcely expect to be entertained with a declamation upon ingratitude, youth, and the vanity of human pursuits, which may seem at first sight to have little to do with the subject in hand. But [. . .] it happens that, in this particular instance, there is an undoubted connexion. In Susan's case, as recorded by Wordsworth, what connexion had the corner of Wood Street with a mountain ascending, a vision of trees, and a nest by the Dove? [. . .] As she stood at that corner of Wood Street, a mop and a pail in her hand most likely, she heard the bird singing, and straightway began pining and yearning for the days of her youth, forgetting the proper business of the pail and mop. Even so we are moved by the sight of some of Mr. Cruikshank's works – the *busen fühlt sich jügendlich erschüttert*, the *schwankende gestalten* of youth flit before one again – Cruikshank's thrush begins to pipe and carol, as in the days of boyhood; hence misty moralities, reflections and sad

and pleasant remembrances arise. He is the friend of the young especially. Have we not read all the story-books that his wonderful pencil has illustrated? Did we not forgo tarts, in order to buy his 'Breaking-up', or his 'Fashionable Monstrosities' of the year eighteen hundred and something? Have we not before us, at this very moment, a print – one of the admirable *Illustrations of Phrenology* – which entire work was purchased by a joint-stock company of boys, each drawing lots afterwards for the separate prints, and taking his choice in rotation? The writer of this, too, had the honour of drawing the first lot, and seized immediately upon 'Philoprogenitiveness' – a marvellous print (our copy is not at all improved by being coloured, which operation we performed on it ourselves) [. . .] – full of ingenuity and fine jovial humour. A father, possessor of an enormous nose and family, is surrounded by the latter who are, some of them, embracing the former. The composition writhes and twists about like the Kermes of Rubens. No less than seven little men and women in night-caps, in frocks, in bibs, in breeches, are clambering about the head, knees, and arms of the man with the nose; their noses, too, are preternaturally developed [. . .]. Not handsome certainly are they, and yet everybody must be charmed with the picture. It is full of grotesque beauty. The artist has at the back of his own skull, we are certain, a huge bump of philoprogenitiveness. He loves children in his heart; every one of those he has drawn is perfectly happy and

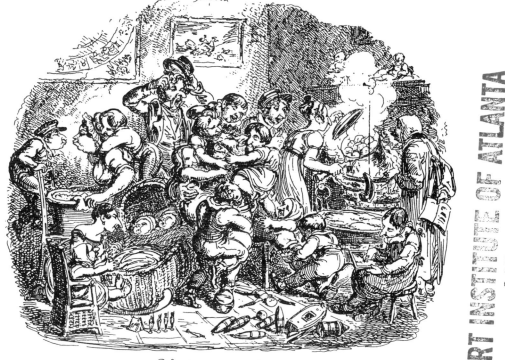

Philoprogenitiveness —

53

jovial, and affectionate, and innocent as possible. He makes them with large noses, but he loves them, and you always find something kind in the midst of his humour, and the ugliness redeemed by a sly touch of beauty. The smiling mother reconciles one with all the hideous family: they have all something of the mother in them – something kind and generous, and tender.

Knight's, in Sweeting's Alley; Fairburn's, in a court off Ludgate Hill; Hone's, in Fleet Street – bright, enchanted palaces, which George Cruikshank used to people with grinning, fantastical imps, and merry, harmless sprites, – where are they? [. . .] How we used to believe in them! to stray miles out of the way on holidays, in order to ponder for an hour before that delightful window in Sweeting's Alley! in walks through Fleet Street, to vanish abruptly down Fairburn's passage, and there make one at his charming 'gratis' exhibition. There used to be a crowd round the window in those days of grinning, good-natured mechanics, who spelt the songs, and spoke them out for the benefit of the company, and who received the points of humour with a general sympathizing roar. Where are these people now? You never hear any laughing at H.B.; his pictures are a great deal too genteel for that – polite points of wit, which strike one as exceedingly clever and pretty, and cause one to smile in a quiet, gentleman-like kind of way.

There must be no smiling with Cruikshank. A man who does not laugh outright is a dullard, and has no heart [. . .]. And there are some of Cruikshank's designs, which have the blessed faculty of creating laughter as often as you see them. [. . .] But though, in our eyes, Mr. Cruikshank reached his *apogée* some eighteen years since, it must not be imagined that such is really the case. Eighteen sets of children have since then learned to love and admire him, and may many more of their successors be brought up in the same delightful faith. It is not the artist who fails, but the men who grow cold – the men, from whom the illusions (why illusions? realities) of youth disappear one by one; who have no leisure to be happy. [. . .] *Pater infelix*, you too have laughed at Clown, and the magic wand of spangled Harlequin; what delightful enchantment did it wave around you, in the golden days 'when George the Third was king!' [. . .]

We know not if Mr. Cruikshank will be very well pleased at finding his name in such company as that of Clown and Harlequin; but he, like them, is certainly the children's friend. His drawings abound in feeling for these little ones, and hideous, as in the course of his duty, he is from time to time compelled to design them, he never sketches one without a certain pity for it, and imparting to the figure a certain grotesque grace. In happy school-boys he revels; plumb-pudding and holidays his needle has engraved over and over again [. . .]. Dull books about children George Cruikshank makes bright with illustrations [. . .]. What a charming and creative power is this, what a privilege – to be a god, and create little worlds upon paper, and whole generations of smiling, jovial men, women and children half-inch high, whose portraits are carried abroad, and have the faculty of making us

54

monsters of six feet curious and happy in our turn. [. . .] Being on the subject of children's books, how shall we enough praise the delightful German nursery-tales, and Cruikshank's illustrations of them? We coupled his name with pantomime awhile since, and sure never pantomimes were more charming than these. Of all the artists that ever drew, from Michael Angelo upwards and downwards, Cruikshank was the man to illustrate these tales, and give them just the proper admixture of the grotesque, the wonderful, and the graceful. [. . .]

It is folly to say that this or that kind of humour is too good for the public, that only a chosen few can relish it. [. . .] Some may have a keener enjoyment of it than others, but all the world can be merry over it, and is always ready to welcome it. The best criterion of good humour is success, and what a share of this has Mr. Cruikshank had! how many millions of mortals has he made happy! We have heard very profound persons talk philosophically of the marvellous and mysterious manner in which he has suited himself to the time – *fait vibrer la fibre populaire* (as Napoleon boasted of himself), supplied a peculiar want felt at a peculiar period, the simple secret of which is, as we take it, that he, living amongst the public, has with them a general wide-hearted sympathy, that he laughs at what they laugh at, that he has a kindly spirit of enjoyment, with not a morsel of mysticism in his composition; that he pities and loves the poor, and jokes at the follies of the great, and that he addresses all in a perfectly sincere and manly way. To be greatly successful as a professional humorist, as in any other calling, a man must be quite honest, and show that his heart is in his work. [. . .] Is any man more remarkable than our artist for telling the truth after his own manner? Hogarth's honesty of purpose was as conspicuous in an earlier time, and we fancy that Gillray would have been far more successful and more powerful but for that unhappy bribe, which turned the whole course of his humour into an unnatural channel. Cruikshank would not for any bribe say what he did not think, or lend his aid to sneer down anything meritorious, or to praise any thing or person that deserved censure. When he levelled his wit against the Regent, and did his very prettiest for the Princess, he most certainly believed, along with the great body of the people whom he represents, that the Princess was the most spotless, pure-mannered darling of a princess that ever married a heartless debauchee of a Prince Royal. [. . .] Cruikshank would not stand by and see a woman ill-used, and so struck in for her rescue, he and the people belabouring with all their might the party who were making the attack, and determining, from pure sympathy and indignation, that the woman must be innocent because her husband treated her so foully. [. . .]

Gin has furnished many subjects to Mr. Cruikshank, who labours in his own sound and hearty way to teach his countrymen the dangers of that drink. In the *Sketch Book* is a plate upon the subject, remarkable for fancy and beauty of design; it is called the 'Gin Juggernaut' [*sic*], and represents a hideous moving palace, with a reeking still at the roof and vast gin-barrels for wheels, under which unhappy millions are crushed to death. An im-

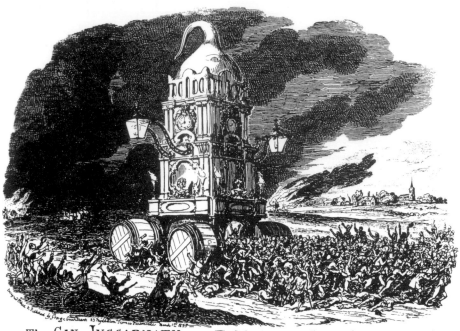

The GIN-JUGGARNATH. Or, The Worship of the GREAT SPIRIT of the age
—— It's Devotees destroy themselves —— It's progress is marked with desolation, misery, and crime ——

mense black cloud of desolation covers over the country through which the gin monster has passed, dimly looming through the darkness whereof you see an agreeable prospect of gibbets with men dangling, burnt houses, &c. The vast cloud comes sweeping on in the wake of this horrible body-crusher; and you see, by way of contrast, a distant, smiling, sunshiny tract of old English country, where gin as yet is not known. The allegory is as good, as earnest, and as fanciful as one of John Bunyan's, and we have often fancied there was a similarity between the men.

The reader will examine the work called *My Sketch Book* with not a little amusement, and may gather from it, as we fancy, a good deal of information regarding the character of the individual man, George Cruikshank. What points strike his eye, as a painter; what move his anger or admiration as a moralist; what classes he seems most especially disposed to observe, and what to ridicule. There are quacks of all kinds, to whom he has a mortal hatred; quack dandies who assume under his pencil, perhaps in his eye, the most grotesque appearance possible – their hats grow larger, their legs infinitely more crooked and lean; the tassels of their canes swell out to a most preposterous size; the tails of their coats dwindle away, and finish where coat-tails generally begin. Let us lay a wager that Cruikshank, a man of the people if ever there was one, heartily hates and despises these supercilious, swaggering young gentlemen; and his contempt is not a whit the less laudable because there may *tant soit peu* of prejudice in it. It is right and wholesome to scorn dandies, as Nelson said it was to hate Frenchmen: in which sentiment (as we have before said) George Cruikshank undoubtedly shares. [. . .]

Against dandy footmen he is particularly severe. He hates idlers, pretenders, boasters, and punishes these fellows as best he may. Who does not recollect the famous picture, 'What *is* Taxes, Thomas?' What is taxes indeed; well may that vast, over-fed, lounging flunky ask the question of his associate Thomas, and yet not well, for all that Thomas says in reply is, *I don't know*.

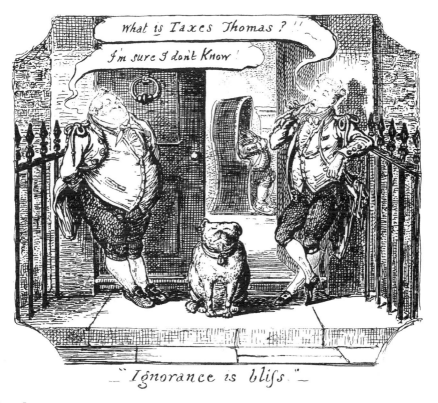

"*Ignorance is bliſs.*"

[. . .] Of late years Mr. Cruikshank has busied himself very much with steel engraving, and the consequences of that lucky invention have been, that his plates are now sold by thousands, where they could only be produced by hundreds before. He has made many a bookseller's and author's fortune (we trust that in so doing he may not have neglected his own). Twelve admirable plates, furnished yearly to that facetious little publication, the *Comic Almanac* [*sic*], have gained for it a sale, as we hear, of nearly twenty thousand copies. The idea of the work was novel; there was, in the first number especially, a great deal of comic power, and Cruikshank's designs were so admirable that the *Almanac* at once became a vast favourite with the public, and has so remained ever since.

Besides the twelve plates, this Almanac contains a prophetic wood-cut, accompanying an awful Blarneyhum Astrologicum that appears in this and other Almanacs. Here is one that [. . .] shows that Rigdum [Funnidos, supposed compiler of the Almanacs], if a true, is also a moral and instruc-

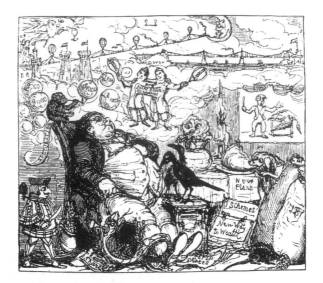

'Show his eyes and grieve his heart;
Come like shadows, so depart.'

tive prophet. Behold John Bull asleep, or rather in a vision; the cunning demon, Speculation, blowing a thousand bright bubbles about him. Meanwhile the rooks are busy at his fob, a knave has cut a cruel hole in his pocket, a rattlesnake has coiled safe round his feet, and will in a trice swallow Bull, chair, money and all; the rats are at his corn bags (as if, poor devil, he had corn to spare), his faithful dog is bolting his leg-of-mutton, nay, a thief has gotten hold of his very candle, and there, by way of moral, is his ale-pot, which looks and winks in his face, and seems to say, O Bull, all this is froth, and a cruel satirical picture of a certain rustic who had a goose that laid certain golden eggs, which goose the rustic slew in expectation of finding all the eggs at once. [. . .] We love these pictures so that it is hard to part us, and we still fondly endeavour to hold on, but this wild word, farewell, must be spoken by the best friends at last, and so good-bye, brave wood-cuts; we feel quite a sadness in coming to the last of our collection. A word or two more have we to say, but no more pretty pictures, – take your last look of the woodcuts then – for not one more will appear after this page – not one more with which the pleased traveller may comfort his eye – a smiling oasis in a desert of text. What could we have done without these excellent merry pictures?

Reader and reviewer would have been tired of listening long since, and would have been comfortably asleep.

[. . .] We should be glad to devote a few pages to the *Illustrations of Time*, the *Scraps and Sketches*, and the *Illustrations of Phrenology*, [. . .] but it is very difficult to find new terms of praise, as find them one must, when reviewing Mr. Cruikshank's publications, and more difficult still (as the

reader of this notice will no doubt have perceived for himself long since) to translate his designs into words, and go to the printer's box for a description of all that fun and humour which the artist can produce by a few skilful turns of his needle. A famous article upon the *Illustrations of Time* appeared some dozen years since in *Blackwood's Magazine*, of which the conductors have always been great admirers of our artist, as became men of humour and genius. To these grand qualities do not let it be supposed that we are laying claim, but, thank Heaven, Cruikshank's humour is so good and benevolent that any man must love it, and on this score we may speak as well as another. [. . .]

A great deal of this random work of course every artist has done in his time, many men produce effects of which they never dreamed, and strike off excellencies, hap-hazard, which gain for them reputation; but a fine quality in Mr. Cruikshank, the quality of his success, as we have said before, is the extraordinary earnestness and good faith with which he executes all he attempts – the ludicrous, the polite, the low, the terrible. In the second of these he often, in our fancy, fails, his figures lacking elegance and descending to caricature; but there is something fine in this too; it is good that he *should* fail, that he should have these honest *naive* notions regarding the *beau monde*, the characteristics of which a namby-pamby tea-party painter could hit off far better than he. He is a great deal too downright and manly to appreciate the flimsy delicacies of small society – you cannot expect a lion to roar you like any sucking dove, or frisk about a drawing-room like a lady's little spaniel. [. . .]

What amazing energetic fecundity do we find in him! As a boy he began to fight for bread, has been hungry (twice a day we trust) ever since, and has been obliged to sell his wit for his bread week by week. And his wit, sterling gold as it is, will find no such purchasers as the fashionable painter's thin pinchbeck who can live comfortably for six weeks when paid for and painting a portrait, and fancies his mind prodigiously occupied all the while. There was an artist in Paris, an artist hair-dresser, who used to be fatigued and take restoratives after inventing a new coiffure. By no such gentle operation of head-dressing has Cruikshank lived: time was (we are told so in print) when for a picture with thirty heads in it he was paid three guineas – a poor week's pittance truly, and a dire week's labour. We make no doubt that the same labour would at present bring him twenty times the sum; but whether it be ill-paid or well, what labour has Mr. Cruikshank's been! Week by week, for thirty years, to produce something new; some smiling offspring of painful labour, quite independent and distinct from its ten thousand jovial brethren; in what hours of sorrow and ill-health to be told by the world, 'Make us laugh or you starve – Give us fresh fun; we have eaten up the old and are hungry.' And all this has he been obliged to do – to wring laughter day by day, sometimes, perhaps, out of want, often certainly from ill-health or depression – to keep the fire of his brain perpetually alight, for the greedy public will give it no leisure to cool. This he has done and done well. He has told a thousand truths in as many

strange and fascinating ways; he has given a thousand new and pleasant thoughts to millions of people; he has never used his wit dishonestly; he has never, in all the exuberance of his frolicsome humour, caused a single painful or guilty blush; how little do we think of the extraordinary power of this man, and how ungrateful we are to him!

Here, as we are come round to the charge of ingratitude, the starting-post from which we set out, perhaps we had better conclude. The reader will perhaps wonder at the high-flown tone in which we speak of the services and merits of an individual, whom he considers a humble scraper on steel, that is wonderfully popular already. But none of us remember all the benefits we owe him; they have come one by one, one driving out the memory of the other: it is only when we come to examine them altogether as the writer has done, who has a pile of books on the table before him – a heap of personal kindnesses from George Cruikshank (not presents, if you please, for we bought, borrowed, or stole every one of them), that we feel what we owe him. Look at one of Mr. Cruikshank's works, and we pronounce him an excellent humorist. Look at all, his reputation is increased by a kind of geometrical progression; as a whole diamond is a hundred times more valuable than the hundred splinters into which it might be broken would be. A fine rough English diamond is this about which we have been writing.

The Bachelor's Own Book

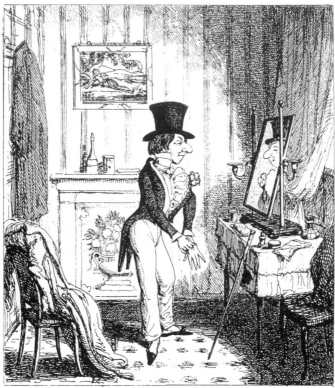

George Cruikshank

Mr. Lambkin having come into his property, enters the world upon the very best possible terms with himself, and makes his toilet to admiration.

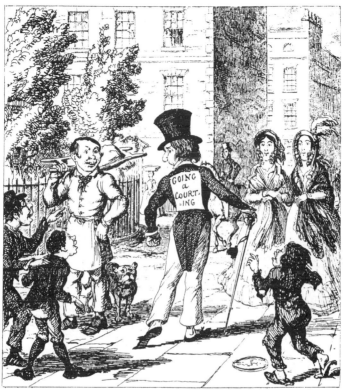

George Cruikshank

Mr. Lambkin sallies forth in all the pride of power, with the secret and amiable intention of killing a certain Lady. Some envious rival makes known this deadly purpose, by means of a placard.

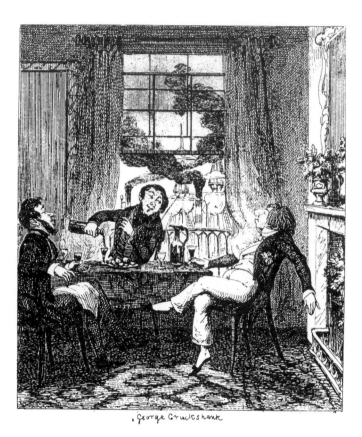

George Cruikshank

Mr. Lambkin with a snug bachelors' party, enjoying his
wine after a most luxurious 'whitebait dinner', at
Blackwall, and talking about his high connexions.

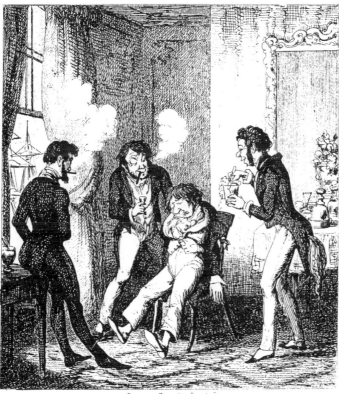

George Cruikshank

Mr. Lambkin suddenly feels rather poorly, something in
the 'whitebait dinner', having disagreed with him,
probably the 'water souchy', or that confounded melted
butter (couldn't possibly have been the wine). His friends
endeavour to relieve him with little drops of brandy, and
large doses of soda water.

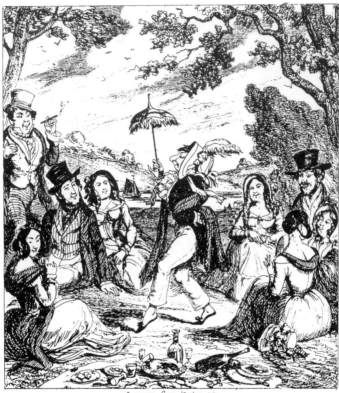

George Cruikshank

Mr. Lambkin, having cut those bachelor parties,
determines to seek the refined pleasures of ladies'
society. He, with the lady of his affections, joins a
pic-nic, endeavours to be exceedingly amusing, and
succeeds in making himself very ridiculous.

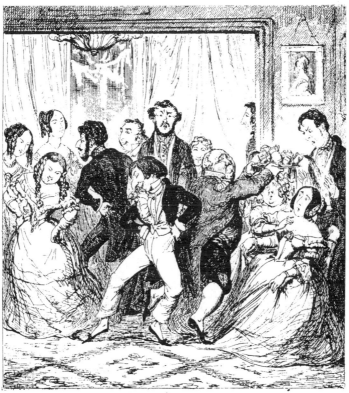

George Cruikshank

Mr. Lambkin, at an evening party, being full of life and spirits (or, rather, wine) gives great offence to the lady of his affections, by his philanderings, and completely ruins his fortunes by dancing the polka with such violence as to upset poor Old John, the coffee, and indeed, the whole party.

George Cruikshank

Mr. Lambkin, overwhelmed with shame and vexation,
resorts to Kensington Gardens in the hope of obtaining a
meeting with the lady of his affections. He burns with
rage, jealousy, and revenge on seeing her (in company
with Miss Dash) holding sprightly converse with the
Long Cornet. He feels himself literally cut.

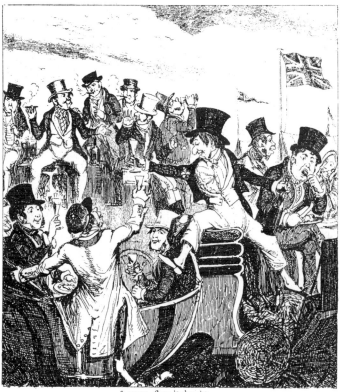

George Cruikshank

After meditating desperate deeds of duelling, prussic
acid, pistols, and plunges in the river, Mr. Lambkin cools
down to a quiet supper, a melancholy reverie, and a
warm bath at The Hummums. The morning sun shines
upon him at Epsom, where, with the assistance of his
friends and champagne, he arrives at such a pitch of
excitement, that he determines to live and die a
bachelor.

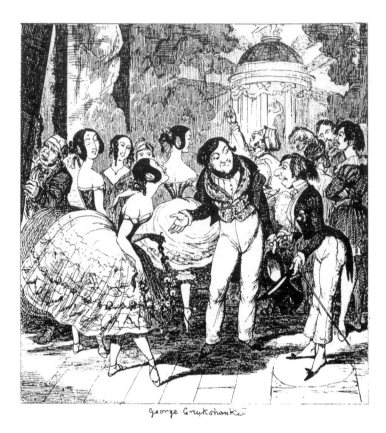

Mr. Lambkin of course visits *all* the theatres and *all* the
saloons; he even makes his way to the stage and the
green-room, and is so fortunate as to be introduced to
some highly talented members of the corps de ballet.

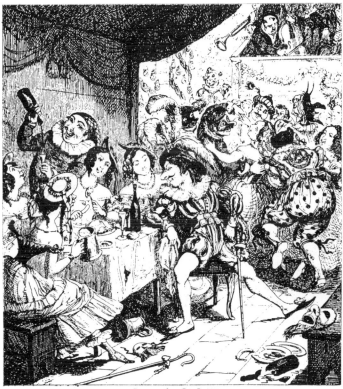

George Cruikshank

Mr. Lambkin goes to a masquerade as Don Giovanni, which character he supports to perfection. He falls into the company of certain Shepherdesses who shew the native simplicity of their arcadian manners by drinking porter out of quart pewter mugs. They are delighted with the Don, who adds to the porter a quantity of champagne, which they drink with the same degree of easy elegance as they do the beer.

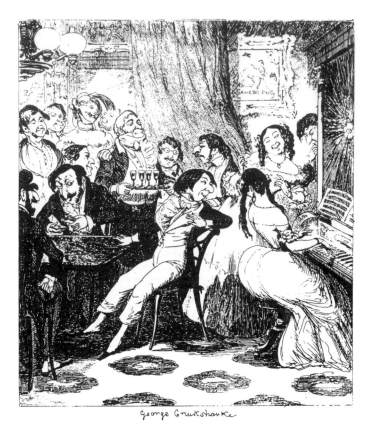

George Cruikshank

Mr. Lambkin makes some most delightful acquaintance:
the Hon. D. Swindelle and his delightful family, his Ma –
such a delightful lady! – and his Sisters, such delightful
girls! Such delightful musical parties, such delightful
soirées, and such delightful card parties, and what makes
it all still more delightful is that they are all so highly
delighted with Mr. Lambkin.

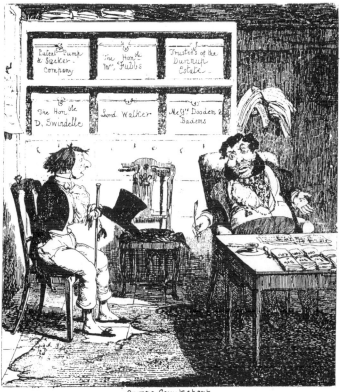

George Cruikshank

Mr. Lambkin in a moment of delightful delirium puts his
name to some little bits of paper to oblige his very
delightful friend the Hon. D. Swindelle, whom he
afterwards discovers to be nothing more than a rascally
black-leg. He is invited to visit some chambers in one of
the small Inns of Court, where he finds himself
completely at the mercy of Messrs. Ogre and Nippers,
whose demands make an awful hole in his Cheque-book.

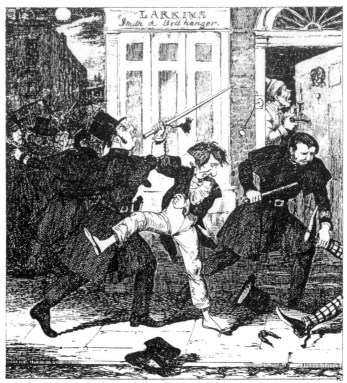

George Cruikshank

Mr. Lambkin and his friends, after supper at 'the rooms',
indulge in the usual nocturnal amusements of gentlemen
– the police officiously interfere with their pastime. Mr.
Lambkin after evincing the noble courage of a lion, the
strength of a bull, the sagacity of a fox, the stubbornness
of a donkey, and the activity of a mountain cat, is at
length overcome by Policeman Smith, A.1.

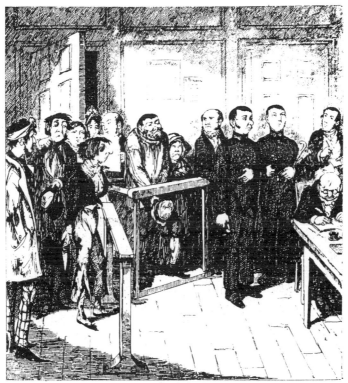

George Cruikshank

Mr. Lambkin and his friends cut a pretty figure in the
morning before the Magistrate – their conduct is
described as violent and outrageous and their
respectability is questioned. Mr. Lambkin and his friends
insist upon being gentlemen, and are, of course,
discharged upon payment of 5s. each for being drunk –
and making good the damage at the prices usually
charged to gentlemen.

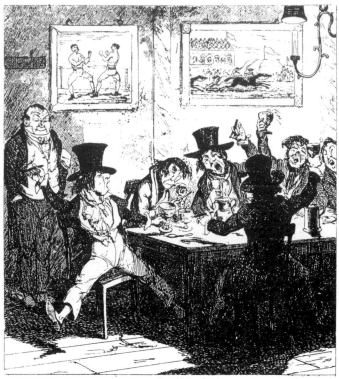

George Cruikshank

Mr. Lambkin, finding that he has been variously and thoroughly befooled, foolishly dashes into dissipation to drown his distressful thoughts. He joins jovial society and sings 'The right end of life is to live and be jolly!'

George Cruikshank

Mr. Lambkin's habits grow worse and worse! – At
3 o'clock a.m. he is placed upright (very jolly) against his
own door, by a kind-hearted cabman.

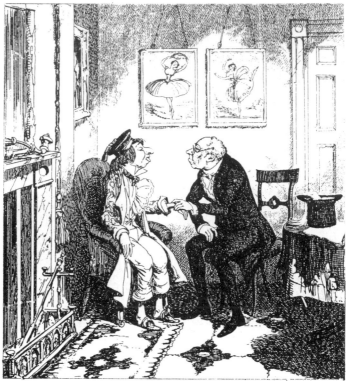

George Cruikshank

Mr. Lambkin finds that he has been going rather too fast in the pursuit of pleasure and amusement, and like all other lads of spirit when he can go no further comes to a stand-still. Being really very ill he sends for his medical friend who feels his pulse, shakes his head at his tongue, and of course prescribes the proper remedies.

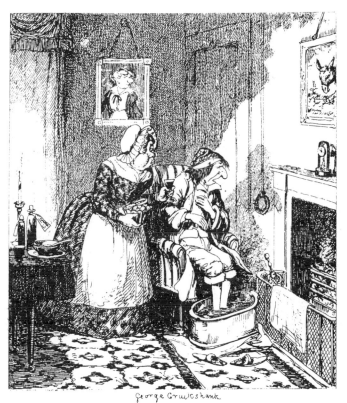

George Cruikshank

Mr. Lambkin has to be nursed, and to go through a
regular course of medicine, taking many a bitter pill and
requiring all the sweet persuasive powers of Mrs. Slops
to take his 'reglar doses' of 'that horrid nasty stuff'.

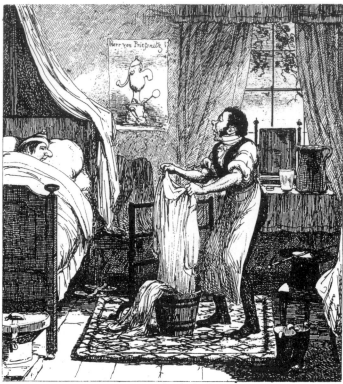

Mr. Lambkin being tired of the old-fashioned regular practice, and being so fortunate as to live in the days when the real properties of water are discovered, places himself under a disciple of the immortal Priessnitz.

George Cruikshank

Mr. Lambkin buys a regular hard-trotter, and combines
the health-restoring exercise of riding with the very great
advantages of wet swaddling clothes.

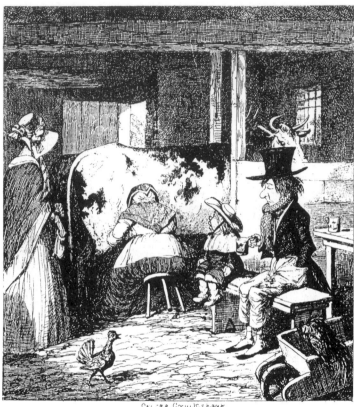

George Cruikshank

Mr. Lambkin's confidence in the curative powers of
hydropathy being very much damped, and being himself
quite soaked through, in fact almost washed away, he
takes to the good old-fashioned practice of walking early
in the morning, and drinking new milk from the cow.

George Cruikshank

Mr. Lambkin being quite recovered, with the aid of new
milk and sea breezes, determines to reform his habits,
but feels buried alive in the Grand Mausoleum Club;
and, contemplating an old bachelor member who sits
poring over the newspapers all day, he feels horror-
struck at the probability of such a fate becoming his own,
and determines to seek a reconciliation with the lady of
his affections.

George Cruikshank

Mr. Lambkin writes a letter of humiliation. – The lady
answers. – He seeks an interview. – It is granted. – He
'hopes she'll forgive him this time'. – The lady appears
resolute. – He earnestly entreats her to 'make it up'. –
At length the lady softens. – She lays aside her 'cruel'
work – ah! She weeps! Silly little thing what does she cry
for? – Mr. Lambkin is forgiven! He skips for joy! Pa and
Ma give their consent.

George Cruikshank

And now let Mr. Lambkin speak for himself. 'Ladies and
Gentlemen, unaccustomed as I am . . . (Bravo) . . .
return . . . (Bravo) on the part of Miss . . . (oh! oh! ha!
ha!). I beg pardon. I mean *Mrs.* Lambkin (Bravo) and
myself for the great . . . hum . . . ha . . . hum . . . and
kindness. (Bravo) In return hum . . . ha . . . pleasure to
drink all your healths (Bravo). – Wishing you all the
happiness this world can afford (Bravo) I shall conclude
in the words of our immortal bard – 'may the single be
married and the (hear! Hear! hear! Bravo) married
happy'. Bravo! Bravo!! Bravo!!!

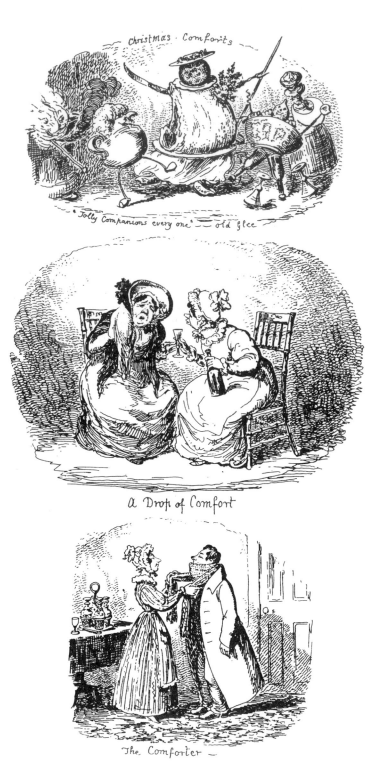

Christmas Comforts

'Jolly Companions every one' — old Glee

A Drop of Comfort

The Comforter —

'Notes on George Cruikshank'

(John Ruskin, 1860–9)

If you ever happen to meet with the two volumes of *Grimm's German Stories*, which were illustrated by him long ago, pounce upon them instantly; the etchings in them are the finest things, next to Rembrandt's, that, as far as I know, have been done since etching was invented. You cannot look at them too much, nor copy them too often.

All his works are very valuable, though disagreeable when they touch on the worst vulgarities of modern life [. . .]. But his manner of work is always right; and his tragic power, though rarely developed, and warped by habits of caricature, is, in reality, as great as his grotesque power.

(*Elements of Drawing*, 1860)

All the real masters of caricature deserve honour in this respect, that their gift is peculiarly their own – innate and incommunicable. No teaching, no hard study, will ever enable other people to equal, in their several ways, the works of Leech or Cruikshank; whereas, the power of pure drawing is communicable, within certain limits, to everyone who has good sight and industry. I do not, indeed, know how far, by devoting the attention to points of character, caricaturist skill may be laboriously attained; but certainly the power is, in the masters of the school, innate from their childhood.

Farther. It is evident that many subjects of thought may be dealt with by this kind of art which are inapproachable by any other, and that its influence over the popular mind must always be great; hence it may often happen that men of strong purpose may rather express themselves in this way (and continue to make such expression a matter of earnest study), than turn to any less influential, though more dignified, or even more intrinsically meritorious, branch of art. And when the powers of quaint fancy are associated (as is frequently the case) with stern understanding of the nature of evil, and tender human sympathy, there results a bitter, or pathetic spirit

87

of grotesque to which mankind at the present day owes more thorough moral teaching than to any branch of art whatsoever.

In poetry, the temper is seen, in perfect manifestation, in the works of Thomas Hood; in art, it is found both in various works of the Germans – their finest and their least thought of; and more or less in the works of George Cruikshank [. . .]. Taken all in all, the works of Cruikshank have the most sterling value of any belonging to this class, produced in England.

(*Modern Painters*, 1860)

Among the foremost men whose power has had to assert itself, though with conquest, yet with countless loss, through peculiarly English disadvantages of circumstance, are assuredly to be ranked together, both for honour and for mourning, Thomas Bewick and George Cruikshank. There is, however, less cause for regret in the instance of Bewick. We may understand that it was well for us once to see what an entirely powerful painter's genius, and an entirely keen and true man's temper, could achieve, together, unhelped, but also unharmed, among the black banks and wolds of Tyne. But the genius of Cruikshank has been cast away in an utterly ghastly and lamentable manner: his superb line-work, worthy of any class of subject, and his powers of conception and composition, of which I cannot venture to estimate the range in their degraded application, having been condemned, by his fate, to be spent either in rude jesting, or in vain war with conditions of vice too low alike for record or rebuke, among the dregs of the British populace. Yet perhaps I am wrong in regretting even this: it may be an appointed lesson for futurity, that the art of the best English etcher in the nineteenth century, spent on illustrations of the lives of burglars and drunkards, should one day be seen in museums beneath Greek vases fretted with drawings of the wars of Troy, or side by side with Dürer's *Knight and Death*.

(*Queen of the Air*, 1869)

The Glass of Fashion

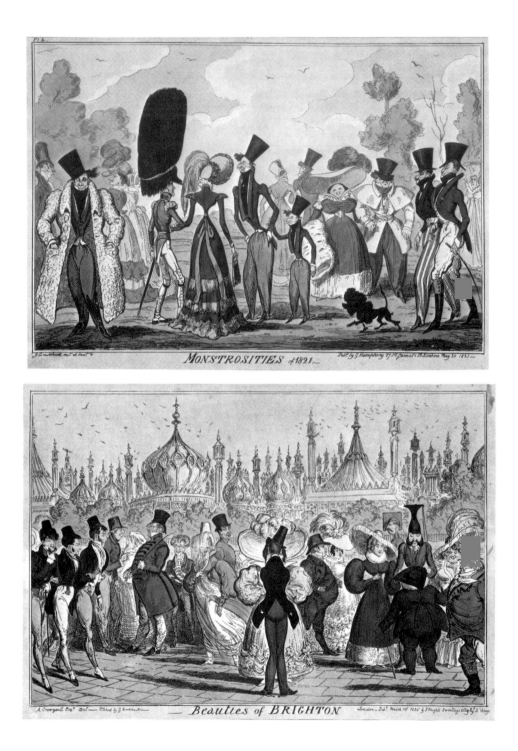

MONSTROSITIES of 1821

Beauties of BRIGHTON

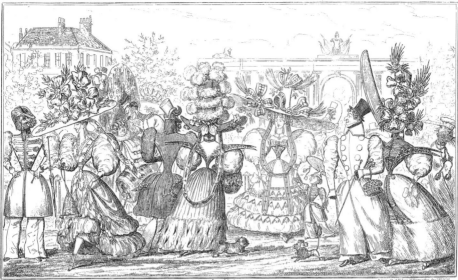

Monstrosities of 1827.—

A Scene in Kensington Gardens or . Fashions and Frights of 1829.— —

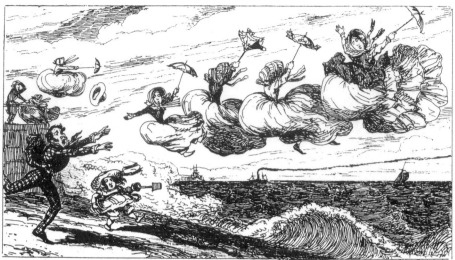

What it must come to, at last, if the Ladies go on blowing them =selves out as they do! George Cruikshank

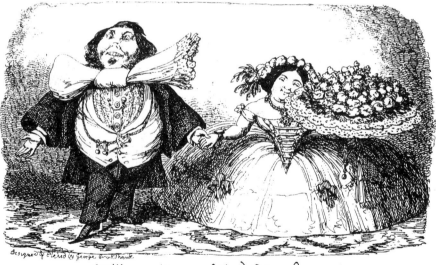

Designed by Etched by George Cruikshank

Will you be —our Vis à Vis? —

The 'Bloomers' in Hyde Park . . .

. . . or an Extraordinary Exhibition for 1852 [details].

A Splendid Spread

George Cruikshank

Bonnet Building

Section of the Bonnet Carriage

'Cruikshank and the Grotesque'

(Charles Baudelaire, 'Some Foreign Caricaturists', 1857)

George Cruikshank's distinctive quality (I leave out of account all his other qualities: delicacy of expression, understanding of the fantastic, etc.) is his inexhaustible abundance of grotesque invention. His verve is unbelievable, and would be dismissed as an impossibility if the evidence were not there, in the form of an immense output, an innumerable collection of vignettes, a long series of comic albums, and, to end with, such a quantity of characters, scenes and physiognomies and grotesque pictures that the viewer's memory loses its bearings; the grotesque flows unceasingly and inevitably from the point of Cruikshank's burin, just as rhyming comes easily to born poets. The grotesque is a habit to him.

If it were possible to analyse with certainty such a fugitive and impalp-

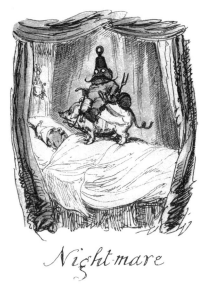

Nightmare

able thing as feeling in art, that indefinable something that always distinguishes one artist from another, however intimate may appear the relationship between them, I would say that the main element in Cruikshank's form of grotesque is the extravagant violence of gesture and movement, and the intensity of expression. All his little figures mime with furious vigour and boisterousness, like actors in pantomime. The only fault that can be attributed to him is that he is often more a man of wit, more a sketcher than an artist, with the result that he does not always draw conscientiously enough. It is almost as though the pleasure he derives from giving full rein to his prodigious verve is such that the author forgets to endow his characters with enough vitality. He is apt to draw rather in the manner of men of letters who amuse themselves in dashing off a few sketches. These amazing little creatures of his are not always born with life in them. All this minute world tumbling over itself, gesticulating, intermingling with indescribable liveliness, does not bother much whether its arms and legs are strictly where nature meant them to be. Too often the figures are no more than the suggestion of human beings, rushing around as best they can. But such as he is, Cruikshank is an artist, endowed with rich comic gifts, and one who will figure in every collection.

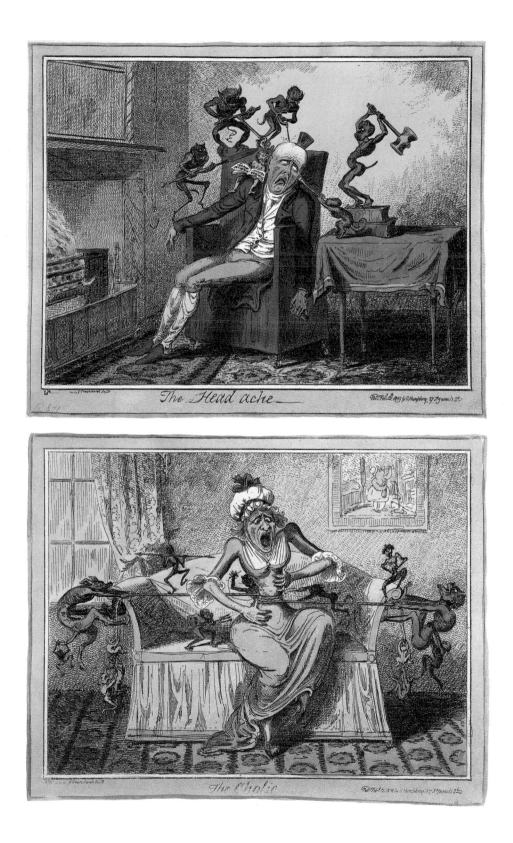

The Head ache

The Cholic

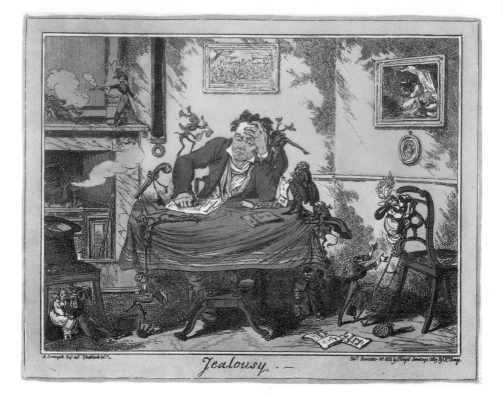

Jealousy. —

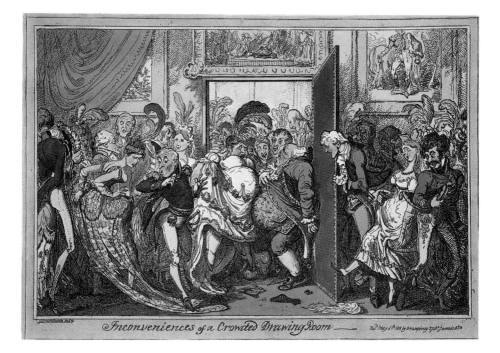

Inconveniences of a Crowded Drawing Room —

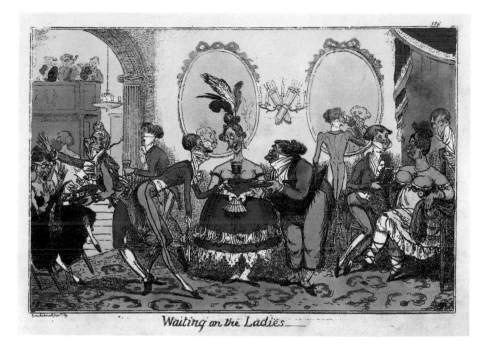

Waiting on the Ladies

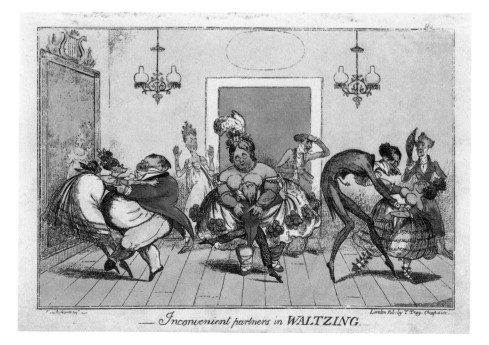

Inconvenient partners in WALTZING.

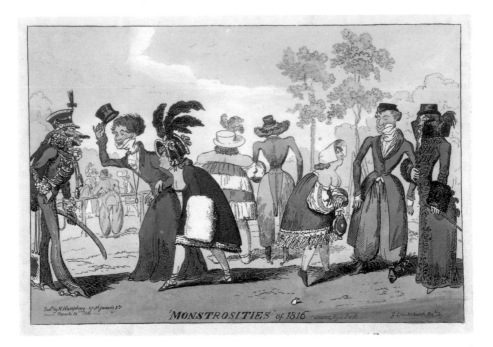

MONSTROSITIES of 1816 — *scene, Hyde Park.*

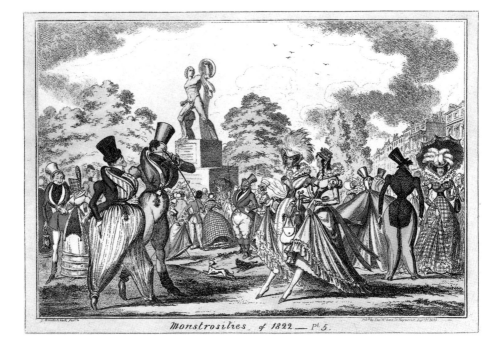

Monstrosities of 1822 — Pl. 5.

The Loving Ballad of Lord Bateman

HISTORY OF
THE LOVING BALLAD
OF LORD BATEMAN

According to Mr. Walter Hamilton, the history of the Loving
Ballad of Lord Bateman *is, that George Cruikshank 'sang the old
English ballad', in the manner of a street-ballad singer, at a dinner
of the Antiquarian Society, at which Dickens and Thackeray were
present. The latter is reported to have remarked, 'I should like to
print that ballad, with illustrations.' But Cruikshank warned him
off, saying that this was exactly what he himself had resolved to do.
The original ballad was much longer than that which Cruikshank
illustrated, and to which Charles Dickens furnished humorous
notes; and was not comic in any respect. Mr Sala's version is the
more* vraisemblant*:*

'The authorship of the ballad itself, which has furnished the basis
for no less than three theatrical burlesques – one by a forgotten
dramatist at the Strand, another by Robert Brough at the Adelphi,
and a third by Henry J. Byron at the Globe – is involved in
mystery. George Cruikshank's assertion, and one to which he
doggedly adhered, was that he heard the song sung one night by an
itinerant minstrel outside a public-house near Battle Bridge; and

98

that he subsequently chanted and 'performed' (George was as good as any play, or as a story-teller in a Moorish coffee-house, at 'performing') the ditty to Charles Dickens, who was so delighted with it that he persuaded George to publish it, adorned with copper-plates. But internal evidence would seem to be against the entire authenticity of the artist's version. That he had heard some doggerel sung outside a tavern, and relating to Lord Bateman, is likely enough. 'Vilikins and his Dinah' was a popular street chanson years before it was immortalized by Robson in Jem Baggs. George Cruikshank's error, it strikes us, was more one of omission than of commission. He may have lyrically narrated the adventures of the 'Noble Lord of High Degree' to Dickens; but he assuredly warbled and 'performed' them too in the presence of Thackeray, who in all probability 'revised and settled' the words, and made them fit for publication. Nobody but Thackeray could have written those lines about 'The young bride's mother, who never before was heard to speak so free', and in the 'Proud Young Porter' all Titmarshian students must recognize the embryo type of James de la Pluche.'

Lord Bateman was Cruikshank's delight. The exquisite foolery expressed in his plates of this eccentric nobleman he would act, at any moment, in any place, to the end of his life. Mr. Percival Leigh remembers a characteristic scene at the Cheshire Cheese tavern, in Fleet Street, about 1842 or 1843. 'This,' he says, 'was in G.C.'s pre-teetotal period. After dinner came drink and smoke, of course; and G.C. was induced to sing 'Billy Taylor', which he did with grotesque expression and action, varied to suit the words. He likewise sang Lord Bateman in his shirt-sleeves, with his coat flung cloakwise over his left arm, whilst he paced up and down, disporting himself with a walking-stick, after the manner of the noble lord, as represented in his illustration to the ballad.'

Six-and-twenty years afterwards we find the bright-hearted old man still with spirits enough for his favourite part.

'One day,' says Mr. Frederick Locker, he asked us to tea, and to hear him sing Lord Bateman, in character, which he did to our infinite delight. He posed in the costume of that deeply interesting but somewhat mysterious nobleman. I am often reminded of the circumstance; for I have a copy of Lord Bateman (1851), and on the false title is written –

This Evening, July 13, 1868,

I sang

LORD BATEMAN

to

My dear little friend, Eleanor Locker.

GEORGE CRUIKSHANK.

This in his seventy-sixth year!

(Blanchard Jerrold, The Loving Ballad of Lord Bateman, 1839)

Warning to the Public

CONCERNING
THE LOVING BALLAD
OF LORD BATEMAN

In some collection of old English Ballads there is an ancient ditty which I am told bears some remote and distant resemblance to the following Epic Poem. I beg to quote the emphatic language of my estimable friend (if he will allow me to call him so), the Black Bear in Piccadilly, and to assure all to whom these presents may come, that '*I* am the original.' This affecting legend is given in the following pages precisely as I have frequently heard it sung on Saturday nights, outside a house of general refreshment (familiarly termed a wine vaults) at Battle-bridge. The singer is a young gentleman who can scarcely have numbered nineteen summers, and who before his last visit to the treadmill, where he was erroneously incarcerated for six months as a vagrant (being unfortunately mistaken for another gentleman), had a very melodious and plaintive tone of voice, which, though it is now somewhat impaired by gruel and such a getting up stairs for so long a period, I hope shortly to find restored. I have taken down the words from his own mouth at different periods, and have been careful to preserve his pronunciation, together with the air to which he does so much justice. Of his execution of it, however, and the intense melancholy which he communicates to such passages of the song as are most susceptible of such an expression, I am unfortunately unable to convey to the reader an adequate

idea, though I may hint that the effect seems to me to be in part produced by the long and mournful drawl on the last two or three words of each verse.

I had intended to have dedicated my imperfect illustrations of this beautiful romance to the young gentleman in question. As I cannot find, however, that he is known among his friends by any other name than 'The Tripe-skewer', which I cannot but consider as a *sobriquet*, or nickname; and as I feel that it would be neither respectful nor proper to address him publicly by that title, I have been compelled to forgo the pleasure. If this should meet his eye, will he pardon my humble attempt to embellish with the pencil the sweet ideas to which he gives such feeling utterance? And will he believe me to remain his devoted admirer,

GEORGE CRUIKSHANK?

N.B. The above is not my writing, nor the notes either, nor am I on familiar terms (but quite the contrary) with the Black Bear. Nevertheless I admit the accuracy of the statement relative to the public singer whose name is unknown, and concur generally in the sentiments above expressed relative to him.

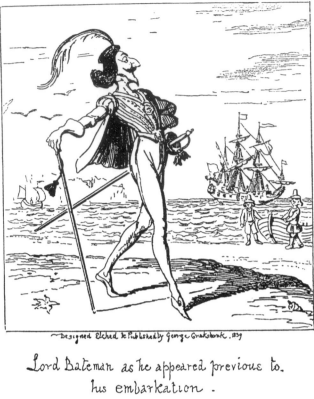

Designed Etched & Published by George Cruikshank. 1839

Lord Bateman as he appeared previous to
his embarkation.

Lord Bateman vos a noble
Lord. A no-ble Lord of high de-
-gree He shipp'd his-self all aboard of a
Ship Some foreign Coun-tree for to
see

THE LOVING BALLAD
OF LORD BATEMAN

I.

Lord Bateman vos a noble Lord,
 A noble Lord of high degree;
He shipped his-self all aboard of a ship,
 Some foreign country for to see.[1]

II.

He sail-ed east, he sail-ed vest,
 Until he come to famèd Tur-key,
 Vere he vos taken and put to prisin,
Until his life was quite wea-ry.

III.

All in this prisin there grew a tree,
 O! there it grew so stout and strong,
 Vere he vos chain-ed all by the middle
Until his life vos almost gone.

[1] *Some foreign country for to see.*

The reader is here in six words artfully made acquainted with Lord
Bateman's character and temperament. – Of a roving, wandering, and
unsettled spirit, his lordship left his native country, bound he knew not
whither. *Some* foreign country he wished to see, and that was the extent of
his desire; any foreign country would answer his purpose – all foreign
countries were alike to him. He was a citizen of the world, and upon the
world of waters, sustained by the daring and reckless impulses of his
heart, he boldly launched. For anything, from pitch-and-toss upwards to
manslaughter, his lordship was prepared. Lord Bateman's character at
this time, and his expedition, would appear to have borne a striking
resemblance to those of Lord Byron.

> His goblets brimmed with every costly wine,
> And all that mote to luxury invite,
> Without a sigh he left to cross the brine,
> And traverse Paynim shores, and pass earth's central line.
> *Childe Harold*, Canto I.

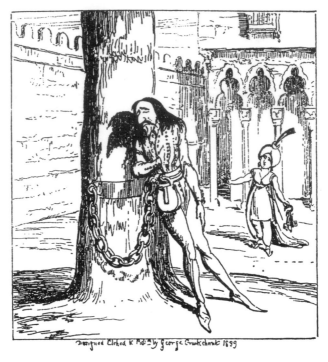

The Turk's only daughter approaches to
mitigate the sufferings of Lord Bateman 2

IV.

This Turk[2] he had one ounly darter,
 The fairest my two eyes e'er see,
She steele the keys of her father's prisin,
 And swore Lord Bateman she would let go free.

[2] *This Turk he had, &c.*

The poet has here, by that bold licence which only genius can venture upon, surmounted the extreme difficulty of introducing any particular Turk, by assuming a foregone conclusion in the reader's mind, and adverting in a casual, careless way to a Turk unknown as to an old acquaintance. '*This* Turk he had – ' We have heard of no Turk before, and yet this familiar introduction satisfies us at once that we know him well. He was a pirate, no doubt, of a cruel and savage disposition, entertaining a hatred of the Christian race, and accustomed to garnish his trees and vines with such stray professors of Christianity as happened to fall into his hands. 'This Turk he had – ' is a master-stroke – a truly Shakespearian touch. There are few things like it in the language.

V.

O she took him to her father's cellar,
 And guv to him the best of vine;
And[3] ev'ry holth she dronk unto him,
 Vos, 'I vish Lord Bateman as you vos mine!'

[3] *And every holth she dronk unto him,*
Vos, 'I vish Lord Bateman as you vos mine!'

A most affecting illustration of the sweetest simplicity, the purest artless-ness, and holiest affections of woman's gentle nature. Bred up among the rough and savage crowds which thronged her father's lawless halls, and meeting with no responsive or kindred spirit among those fierce barbar-ians (many of whom, however, touched by her surpassing charms, though insensible to her virtues and mental endowments, had vainly sought her hand in marriage), this young creature had spent the greater part of her life in the solitude of her own apartments, or in contemplating the charms of nature arrayed in all the luxury of Eastern voluptuousness. At length she hears from an aged and garrulous attendant, her only female adviser (for her mother died when she was yet an infant), of the sorrows and sufferings of the Christian captive. Urged by pity and womanly sympathy, she repairs to his prison to succour and console him. She supports his feeble and tottering steps to her father's cellar, recruits his exhausted frame with copious draughts of sparkling wine, and when his dim eye brightens, and his pale cheek becomes flushed with the glow of returning health and animation, she – unaccustomed to disguise or concealment, and being by nature all openness and truth – gives vent to the feelings which now thrill her maiden heart for the first time, in the rich gush of unspeakable love, tenderness and devotion –

I vish Lord Bateman as you vos mine!'

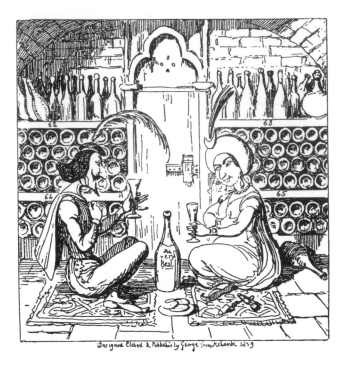

Designed Etched & Published by George Cruikshank 1839

The Turks daughter expresses a wish
as Lord Bateman was hers.

VI.

'O have you got houses, have you got land,
 And does Northumberland belong to thee?
And what would you give to the fair young lady
 As out of prisin would let you go free?'

VII.

'O I've got houses, and I've got land,
 And half Northumberland belongs to me:
And I vill give it all to the fair young lady
 As out of prisin vould let me go free.'

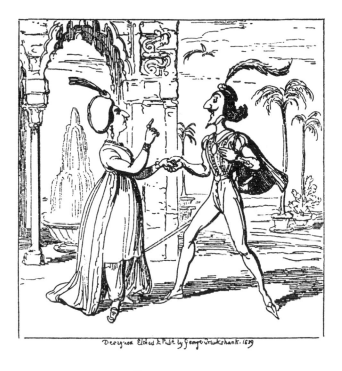

Designed Etched & Publd by George Cruikshank. 1839

The "Wow."

VIII.

'O in[4] sevin long years, I'll make a wow
 For sevin long years, and keep it strong,
That if you'll ved no other voman,
 O I vill v-e-ed no other man.'

[4] '*O, in sevin long years I'll make a wow,*
 I'll make a wow, and I'll keep it strong [sic]'

Love has converted the tender girl into a majestic heroine; she can not only make 'a wow' but she can 'keep it strong'; she feels all the dignity of truth and love swelling in her bosom. With the view of possessing herself of the real state of Lord Bateman's affections, and with no sordid or mercenary motives, she has inquired of that nobleman what are his means of subsistence, and whether *all* Northumberland belongs to him. His lordship has rejoined, with a noble regard for truth, that *half* Northumberland is his, and that he will give it freely to the fair young lady who will release him from his dungeon. She, being thus assured of his regard and esteem, rejects all idea of pecuniary reward, and offers to be a party to a solemn wow – to be kept strong on both sides – that, if for seven years he will remain a bachelor, she, for the like period, will remain a maid. The contract is made, and the lovers are solemnly contracted.

107

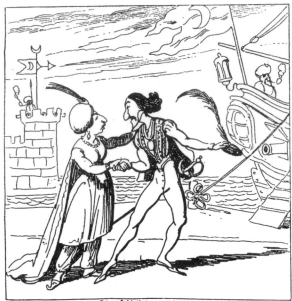

Designed Etched & Published by George Cruikshank 1839

The Turk's daughter, bidding his Lordship farewell, is impressed with a foreboding that she will see him no more !—

IX.

O she took him to her father's harbour,
　　And guv to him a ship of fame,
Saying, 'Farevell, farevell to you, Lord Bateman,
　　I fear I ne-e-ver shall see you agen.'

X.

Now[5] sevin long years is gone and past,
　　And fourteen days vell known to me;
She packed up all her gay clouthing,
　　And swore Lord Bateman she would go see.

[5] *Now sevin long years is gone and past,*
　　And fourteen days vell known to me.

In this may be recognized, though in a minor degree, the same gifted hand that portrayed the Mussulman, the pirate, the father, and the bigot, in two words. The time is gone, the historian knows it, and that is enough for the reader. This is the dignity of history very strikingly exemplified.

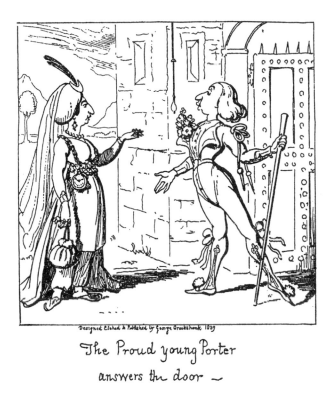

The Proud young Porter
answers the door

XI.

O ven she arrived at Lord Bateman's castle,
　　How bouldly then she rang the bell,
'Who's there? who's there?' cries the proud
　　　　young porter,
'O come, unto me pray quickly tell.'

XII.

'O! is this here Lord Bateman's castle,
　　And is his lordship here vithin?'
'O yes! O yes!' cries the proud young porter;
　　'He's just now takin' his young bride in.'

XIII.

'O! bid him to send me a slice of bread,
　　And a bottle of the wery best vine,
And not forgettin' the fair young lady.
　　As did release him ven close confine.'

109

XIV.

O! avay and avay vent this proud young porter,
 Oh! avay and avay and avay vent he,[6]
Until he came to Lord Bateman's charmber,
 Ven he vent down on his bended knee.

XV.

'Vot news, vot news, my proud young porter,[7]
 Vot news, vot news, come tell to me?'
'O there is the fairest young lady
 As ever my two eyes did see.

XVI.

'She has got rings on ev'ry finger,
 And on one finger she has got three:
Vith as much gay gould about her middle
 As would buy half Northumberlee.

[6] *Avay and avay vent this proud young porter,*
 Avay and avay and avay vent he [*sic*].

Nothing perhaps could be more ingeniously contrived to express the vastness of Lord Bateman's family mansion than this remarkable passage. The proud young porter had to thread courts, corridors, galleries, and staircases, innumerable, before he could penetrate to those exquisite apartments in which Lord Bateman was wont to solace his leisure hours with the most refined pleasures of his time. We behold him hastening to the presence of his lord; the repetition of the word 'avay' causes us to feel the speed with which he hastens – at length he arrives. Does he appear before the chief with indecent haste? Is he described as rushing madly into his presence to impart his message? No! a different atmosphere surrounds that remarkable man. Even this proud young porter is checked in his impetuous career, which lasted only

> *Until* he came to Lord Bateman's charmber,
> Vere he vent down on his bended knee.

Lord Bateman's eye is upon him, and he quails.

[7] *'Vot news, vot news, my proud young porter?'*

A pleasant condescension on the part of his lordship, showing that he recognized the stately youth, and no less stately pride of office which characterized his follower, and that he was acquainted with the distinguishing appellation which he appears to have borne in the family.

110

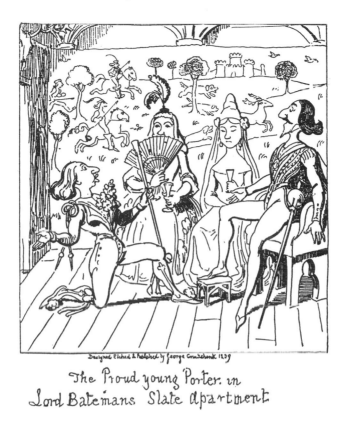

The Proud young Porter, in
Lord Batemans Slate Apartment

Designed, Etched & Published by George Cruikshank 1839

XVII.

'O she bids you send her a slice of bread
 And a bottle of the wery best vine,
And not forgettin' the fair young lady
 As did release you ven close confine.'

The young bride's Mother is heard
(for the first time) to speak freely !—

XVIII.

Lord Bateman then in passion flew
And broke his sword in splinters three,[8]
Saying, 'I vill give half may father's land
If so be as Sophia[9] has crossed the sea.'

[8] *And broke his sword in splinters three.*

Exemplifying, in a highly poetical and striking manner, the force of Lord
Bateman's love, which he would seem to have kept strong as his 'wow'.
We have beheld him patient in confinement, descending to no base
murmurings against fortune, even when chained by the middle to a tree,
with the prospect of ending his days in that ignominious and unpleasant
position. He had borne all this and a great deal more, seven years and a
fortnight have elapsed, and, at last, on the mere mention of the fair young
lady, he falls into a perfect phrenzy, and breaks his sword, the faithful
partner and companion of his glory, into three splinters. Antiquarians
differ respecting the intent and meaning of this ceremony, which has been
construed and interpreted in many different ways. The strong possibility is
that it was done 'for luck'; and yet Lord Bateman should have been
superior to the prejudices of the vulgar.

[9] *'If my own Sophia [sic]'.*

So called doubtless from the mosque of St Sophia, at Constantinople; her
father having professed the Mahomedan religion.

112

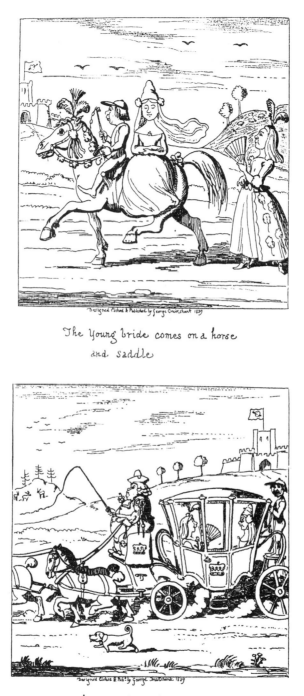

The young bride comes on a horse
and saddle

— And goes home in a coach
and three — —

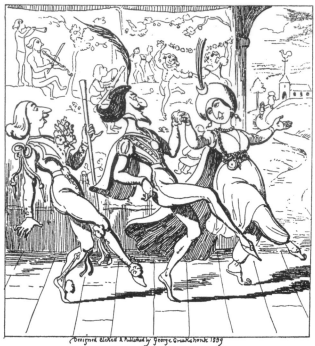

Lord Bateman, his other bride, and his favorite
domestic, with all their hearts so full of glee.

XIX.

Then up and spoke this young bride's mother,
 Who never vos heerd to speak so free:[10]
Sayin, 'You'll not forget my ounly darter,
 If so be as Sophia has crossed the sea.'

[10] *Then up and spoke this young bride's mother,*
 Who never vos heerd to speak so free.

This is an exquisite touch of nature, which most married men, whether of
noble or plebeian blood, will quickly recognize. During the whole of her
daughter's courtship, the good old lady had scarcely spoken, save by
expressive smiles and looks of approval. But now that her object is gained,
and her daughter fast married (as she thinks), she suddenly assumes quite
a new tone, 'and never vos heerd to speak so free'. It would be difficult for
poetry to comprehend anything more strictly true and life-like than this.

XX.

'O it's true I made a bride of your darter,
　　But you'll see what I'll do for you and she;
She came to me on a horse and saddle,
　　But she shall go home in a coach and three.'

XXI.

Lord Bateman then prepared another marriage,
　　With both their hearts so full of glee,[11]
Saying, 'I vill roam no more to foreign countries
　　Now that Sophia has crossed the sea.'

[11] *With both their hearts so full of glee.*

If anything could add to the grace and beauty of the poem, it would be this most satisfactory and agreeable conclusion. At the time of the foreign lady's arrival on the shores of England, we find Lord Bateman in the disagreeable dilemma of having contracted another marriage; to which step his lordship has doubtless been impelled by despair of ever recovering his lost Sophia, and a natural anxiety not to die without leaving an heir to his estate. The ceremony has been performed, the Church has done its office, the bride and her mamma have taken possession of the castle, when the lost Sophia suddenly presents herself. An ordinary man would have been overwhelmed by such a complication of perplexities – not so Lord Bateman. Master of the human heart, he appeals to feminine ambition and love of display; and, reminding the young lady that she came to him on a saddle horse (with her revered parent following no doubt on foot behind), offers to bestow upon her a coach and three. The young lady closes with the proposition; her august mother, having brought it about by her freedom of speech, makes no objection; Lord Bateman, being a nobleman of great power, and having plenty of superfluous wealth to bestow upon the Church, orders another marriage, and boldly declares the first one to be a nullity. Thereupon 'another marriage' is immediately prepared, and the piece closes with a picture of general happiness and hilarity.

THE END

'The Other Genius of
English Caricature'

(Sir Sacheverell Sitwell, *Narrative Pictures*, 1937)

It is pleasant also to look at George Cruikshank, [. . .] one of the very greatest of English artists. Cruikshank is, and must always be immortal, for he is the delineator of London life from the days of the Regency down till the Crystal Palace and the Great Exhibition.

[. . .] It is, naturally, his more extreme efforts in caricature that are the most interesting. His obsessions load and populate his stage, for they have the character, in fact, of nightmare pantomime. The unrealities become material and, for a moment, in defiance of every law of life, they play their incredible parts. It is upon these inspired occasions that we see this morbid fantasist in his true light as a genius of invention and elaboration. In these respects Gillray has no equal.

There is a tradition that the other genius of English caricature was called in by Mrs. Humphreys, the publisher and printseller of St. James's Street, in whose house Gillray had lived for so many years, in order that he should complete the plates upon which Gillray had been engaged until his illness made it hopeless for him to proceed any further. George Cruikshank, who was born in 1792, would have been at that time, in 1811 or 1812, some twenty years of age. It is certain, even, that he had seen and spoken to Gillray, and for these reasons the early work of Cruikshank is definitely in the idiom of Gillray. [. . .] Perhaps the original Cruikshank appears for the first time in his travesties of the fashions, a series entitled Fashionable Monstrosities. These must be familiar to nearly everyone. The years from 1815 to 1825 were a time of mad fantasy in dress, fostered by the Prince Regent himself, in his character as the best-dressed man in Europe. The collection published under the name of *Cruikshankiana*, in 1830, contains a number of these. [. . .]

Just before this time Cruikshank had developed into more than one new direction. It is to be seen, first of all, in his etchings to *Peter Schlemihl*, [. . .] followed immediately by his plates to *Grimm's Fairy Tales* and to *Grimm's Popular Stories*. These etchings, which were so much admired by

116

Ruskin, are among the lesser masterpieces of the Romantic Movement. [. . .] A year or two previously, *Life in Paris*, with its coloured plates and smaller woodcuts, had marked the culmination, as it were, of his early phase. These plates, it must be noted, like those drawn by Rowlandson to *Letters from the Campagna Felice*, were taken from sketches by an amateur. Cruikshank had never been to Paris. In fact, like his predecessor Hogarth, he never went further abroad than a day trip to France, in this case to Boulogne. In 1826 the coloured aquatints to *Greenwich Hospital* were published. These show Cruikshank in another of his *fortes*, which consisted in his studies of sailors. [. . .] From this point it would be hopeless to attempt to keep pace with his tremendous output. Enough may be said, however, to establish the main lines of his development.

This proceeded into many directions at one and the same time. There are those, for instance, who would prefer the two series of *Mornings at Bow Street*, or *My Sketch Book*. On the other hand, the seventeen volumes of the Novelists' Library, consisting of his drawings to Smollett, Goldsmith, Fielding, Sterne, etc., etc., mark his first adventures into the historical style. For our own part, our predilection at this period is for *The Comic Almanack*, a most wonderful compilation of his wit and invention, which ran from 1835 until 1853. This contains an illustration for each of the months, as well as innumerable smaller drawings and decorations. London is to be seen in its true character in *The Comic Almanack*, for this is Cruikshank at his inimitable best. Any one volume seems to hold the present as well as the dead past, of this smoky metropolis. We remember, particularly, August in London, with passers-by eating from the first oyster stall, a hoarding covered with posters, a London lamp-post – everything that is most characteristic of London. [. . .] Two more attempts in the manner of *The Comic Almanack* were *George Cruikshank's Omnibus* and the *Table Book*, both containing some of his best work, but doomed as failures. [. . .]

There are some, indeed, to whom Cruikshank is the major English artist of the nineteenth century. The long span of his life covers the whole of the first three-quarters of that period. He remembered the eighteenth century and lived until just short of the eighteen-eighties. [. . .] The drawings in illustration of his projected Autobiography, upon which he was engaged in the 'seventies, just before his death, are occupied entirely with the eighteenth-century scene of his childhood. In point of etching they amount to little more than casual, haphazard scratchings of his needle, but they are instinct with a childhood passed three generations before. Cruikshank has, it may be, a special appeal in this time when the essential London is being attacked and demolished on all sides. For his genius gives us, not only its appearance, but the entire population of its streets and houses. He is the delineator of London as surely as Canaletto or Guardi are the painters of Venice. But Cruikshank is many other things as well. He is among the first artists to attempt historical accuracy in their reconstruction of the past. The proofs of this are the seventeen volumes of the Novelists' Library, and his illustrations to Harrison Ainsworth. [. . .]

The personality of *Cruikshank* was, in its nature, the gift or talent of a prodigy. It found full expression within the space of a few square inches. He had a personal touch which [. . .] we might compare, in degree, with that of Marcellus Laroon. It is unmistakable and not to be confused with that of any one of his contemporaries. He has a canon of proportion which is all his own and which we could term his convention. This corresponds, as a vehicle for his humour and observation, with the strange conventions of many popular comedians, with the immense shoes of Little Tich, or the bowler hat and black eyebrows of George Robey. It is only by thus establishing themselves out of the ordinary world that they can create their satires. Their segregation from the world puts them upon the plane of creation. In order to create character they have to be as disguised, and as extreme in that, as any priest or witch doctor. It is the same with the vehicle of the caricaturist. Only, in the case of Cruikshank, we are to assume that he was born with it, and that it was his natural channel of expression. Also, in the very nature of things, their touch, their identity must be at once known to the public. This is, in fact, another reason for the establishment of their peculiar convention. But his idiom was the natural speech of Cruikshank. Like a personal accent of the voice it was a thing which he could never part from. It informs each and every one of his undertakings. [. . .] His unchanged personality is his exceptional merit. It is Cruikshank, in fact, who created his own peculiar world. That is his own personal property, and only by the labour of his hands could it come to life. It is, therefore, the true measure of his greatness.

Zoological
Fancies

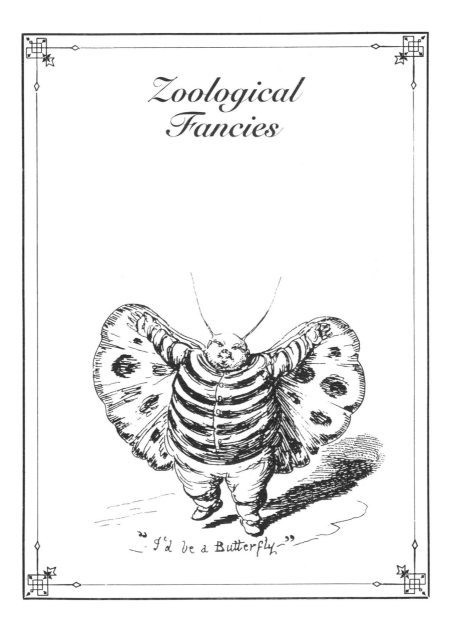

"I'd be a Butterfly"

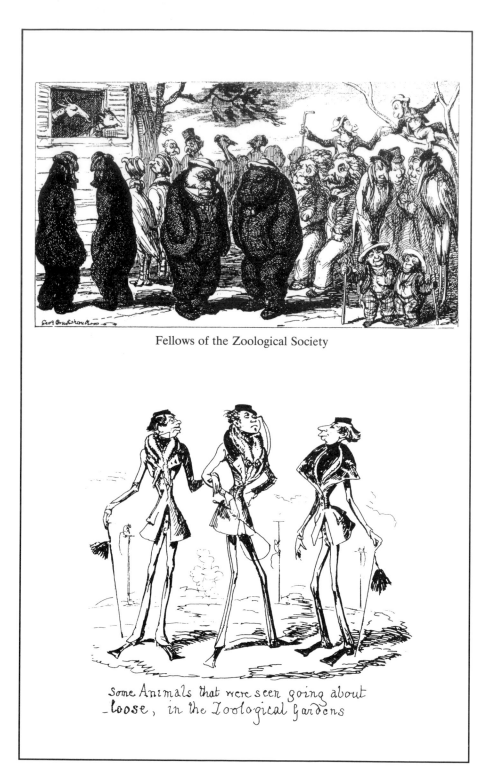

Fellows of the Zoological Society

Some Animals that were seen going about loose, in the Zoological Gardens

SOCIAL ZOOLOGY

[. . .]While doing ample justice to the great writers on animated nature who have preceded us, we still think that they have left a great want unsupplied, by neglecting to favour us with a few chapters on what may be termed Social Zoology [. . .] We intend, therefore, supplying as well as we can the gap which seems to exist, by providing a sort of handbook to the zoology of every-day life, for the purpose of describing the various disagreeable brutes, strange birds, and odd fishes, that are constantly met with in society. [. . .]

The Lion of an evening party belongs to a species of which there are several *genera*, or different kinds. The great or principal Lion may, however, be known by the length of his tail, for every one will be running after him. [. . .] He will often be induced to go a considerable distance for a meal, and if he is well fed upon what he likes, he will mix condescendingly with the inferior animals about him, and make himself very agreeable. [. . .]

The Lion chiefly comes forth at night, but he may be seen sometimes in the afternoon, prowling about the wood – pavement – or seeking for food among those who, he thinks, will take him to their homes and give him the meal he is in search of. [. . .]

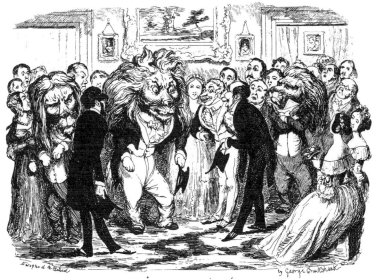

The *Lion* of the party !

A musical Lion is a very formidable beast, for when he once begins to roar there is no stopping him. The musical Lion is so fond of hearing his own voice that he will growl for an hour at a time, and there is no possibility of muzzling the brute or getting rid of him.

The literary Lion is chiefly remarkable for the contrast between the ferocity of his aspect and the mildness of his demeanour. [. . .] His coat, which looks so sleek and glossy at night, is often quite another thing by daylight, and narrow white stripes are sometimes visible. This is chiefly to be observed in those Lions which very seldom shed their coats; and there are some who do not obtain a new coat without very great difficulty. Lions of this description are timid and retiring by day, and at night they appear to resume all their courage. They inhabit chiefly the most elevated spots, and will climb patiently to a very considerable height to reach their resting-place. This sort of Lion seldom appears abroad with his cubs, if he happens to have any. [. . .]

The literary Lioness is becoming a very common animal, and though exceedingly harmless, she is hardly ever subject to be pursued, for everyone instinctively flies away from her.

Of all the animals comprised within the wide range of Social Zoology, none is more objectionable than the Boar, or to use another mode of orthography – the Bore. He comes under the head of Pachydermata, or thick-skinned animals, and is so extremely callous, that hit at him as hard as you may, it is impossible to make any impression on him. He does not belong to the Ruminantia, or ruminating animals; but must be classed among the Omnivora, for the Bore has a rapacious appetite, and frequently comes in to satisfy his cravings at about feeding-time. It is a remarkable fact that, though belonging to the Pachydermata, or thick-skinned order of brutes, he would seem, from the softness of the head and brains, to belong to the group of Molluscous animals. He is also allied to this class by the possession of another quality, namely, that of remaining, like the Mollusca, long fixed in the same place, for when the social Bore has once taken up his quarters, it is very difficult indeed to get rid of him. The Bore is of

the Hog tribe, and is guided a good deal by the snout, for he pokes his nose everywhere. [. . .]

The snout of the Bore is also useful to him in more ways than one, for his scent is truly wonderful, enabling the brute to smell out a good dinner at three or four miles distance. In a natural state – that is, when he is at home – the Bore is often found to feed upon the coarsest fare; but when he has succeeded in meeting with prey abroad, he becomes very delicate, selecting only the choicest morsels, and grunting savagely if he is not pleased with what is before him. The Bore is not generally a dangerous animal, though the well-known expression, 'bored to death', would seem to indicate otherwise. When the brute contemplates making an attack, he usually fastens himself on his victim by seizing the button, and has been known to retain his hold on his prey in this manner for hours together.

The female Bore is chiefly remarkable for her numerous progeny. She will appear surrounded by an extensive litter of little ones, who will sometimes be exceedingly frolicsome. They will jump up into your lap, put their paws into your plate, and play all sorts of antics if you give them the least encouragement. [. . .]

When looking at Social Zoology in all its branches, we cannot omit the birds; which may be said to perch on several branches of

A horrible Bore, in the Company.

the great tree of Natural History. We shall therefore favour our readers with a little ornithology. [. . .]

The first order of birds we shall pounce upon, are those who are always pouncing upon others – namely, the Raptores, or birds of prey, which include the Vulturidæ or tribe of Vultures. These dreadful creatures are of various kinds, but the great long-billed or lawyer Vulture is the most formidable of any. He is among birds what the tiger is among brutes; and in fact, though not absolutely of the cat class, the lawyer Vulture belongs to the fee-line order. He has monstrous quills, which are of great use to him, and his claws are very strong. He often builds his nest in the gloomy arches of old Temples – the Inner and the Middle – from which he watches his prey with great eagerness. The bill is the most formidable part of these birds, who sometimes stick it into their victim with the most unsparing vehemence. It is said they only follow Nature's common law in providing for themselves; but Nature's common law should sometimes be restrained by an injunction from the superior Court of Equity. Many of the lawyer birds are tame and amiable creatures, acting as the friends and companions of man, instead of being his constant enemies. These are, however, a somewhat different class, with much shorter bills, and not so black in their plumage.

Next to the Social Vultures come the Hawks, who are the subordinates of the class we have just described, and are often employed in hunting up the prey that the former feed upon. The Hawks, however, take care to get a good share for themselves before placing the victim in the Vulture's clutches. The Hawk may be called the bailiff bird, and is superior to the Vulture in the pursuit of prey. [. . .] The Hawk, or bailiff-bird, is now becoming extinct, and has degenerated into a sort of blue finch or police cock-sparrow, who is marked with a zebra's stripe, as if to show his relationship to the ordinary, or rather the extraordinary, jackass.

There is another species of Hawk, called the Gambler-bird, whose prey is the pigeon, which is sometimes completely plucked by its oppressor, and when it has nothing more left, its persecutor will often take from it its bill, which frequently proves to be valueless. [. . .] The Jail-bird is, when it can be caught, kept confined in strong iron cages. There are several specimens to be seen in the public aviaries, but there is sometimes great difficulty in catching them, on account of their very shy disposition. They bear a great resemblance to the owl when in their free state, being nocturnal birds of prey, and [. . .] though, like the owls, they are very knowing birds, their short-sightedness is proverbial. [. . .] The Jail-bird is always very sensitive when it is being pursued, and can generally tell by instinct if there are any beaks coming after it.

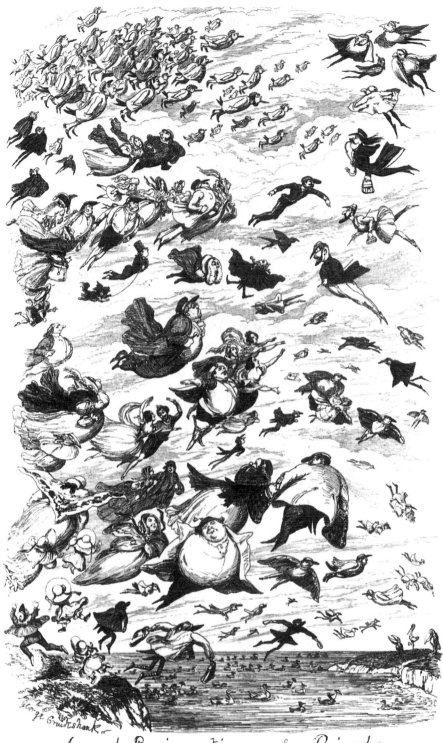

Annual Emigration of Birds.

Among the birds that form a very extensive class in Social Zoology, are the Boobies, who share with other birds to a great extent the practice of an annual migration across the water. They are often followed by Rooks, and waited for on the other side by Hawks, between whom the Boobies are sadly victimized. The Social Booby walks with difficulty, and in fact cannot get on. He frequents the ledges of rocks, and indeed always seems to be blundering on to the edge of a precipice.

The Booby

We have already alluded to the annual migration of the feathered tribe, and the Italian singing-birds who visit our clime every year invariably take their flight at the beginning of August. [. . .] It is a peculiarity of these birds that they are generally successfully occupied in feathering their nests while they remain in England.

The Goldfinch is a British bird that invariably migrates in the course of the year, and sometimes remains abroad for a long period. [. . .]

The native Bullfinch generally migrates with his mate and little ones, but frequently is contented with going only as far as the seaside, without crossing over. He is often much afraid of Mother Carey and her celebrated chickens. But these fearful birds exist only in the imagination of the Bullfinch. Birds of this description are distinguished from the Raptores, or birds of prey, by the term Natatores, or waders; and at the annual migration, even 'the ducks and the geese they all swim over', if they can find an opportunity. There are a few birds of doubtful character that hop the twig suddenly when the season is past, and are never seen afterwards.

Spoon-bill —

Social Ornithology comprises a few other birds we have not already mentioned, including the Gull and the Spoon-bill. The former is remarkable for its digestion, and will swallow anything.

The Spoon-bill is a sort of adjutant to the Wild Goose, and this accounts for the fact of the Spoon-bill going very frequently on Wild Goose errands.

(Gilbert a' Beckett, *George Cruikshank's Table Book*, 1845)

Birds of Paradise

Zoological Sketches

Designed Etched
& Published by
George Cruikshank
April 1st 1834

Tom Tit

Black-bird

Bottle-nose

Gigantic Crane

Bearded Griffin

A Species of Macaw
(NB These Birds generally Stuff well)

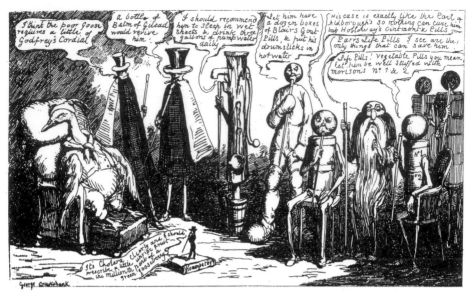

The Sick Goose and the Council of Health

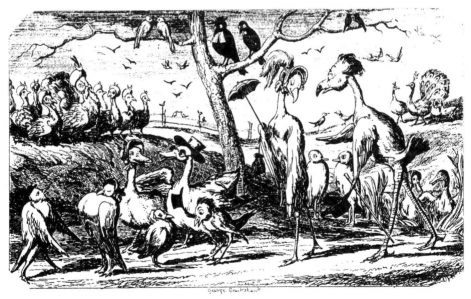

Curiosities of Ornithology

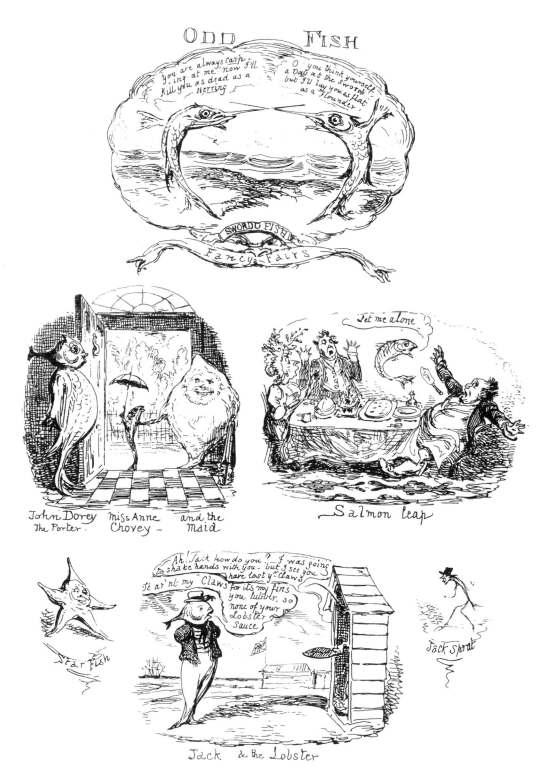

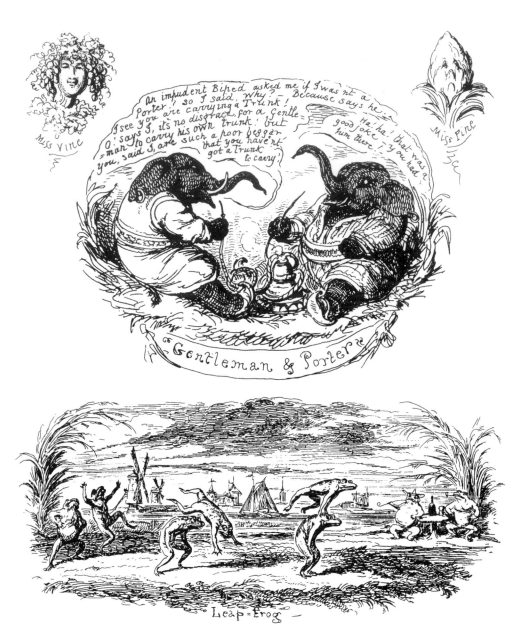

'The Clown in White Gloves'

(Sir David Low, *British Cartoonists, Caricaturists and Comic Artists*, 1942)

[. . .] At first the brothers Cruikshank were closely associated and it is probable that many early drawings were the joint work of both; but later they separated and came to the point of quarrelling with each other about their respective rights to sign with the plain surname 'Cruikshank'. Since, owing to this dispute, the brothers often would omit to sign their drawings at all, it is occasionally hard to identify the work of either except by a careful study of style and technique.

Difficulty in this respect is not lessened by the fact that George was an obliging fellow without any political conscience, ready not only to draw to order squibs against any policy, person or thing that could pay him his fee, but also to build up compositions of draughtsmanship from the 'roughs' supplied by friends and clients, and to etch on the plates designs which were completely the work of other artists.

Robert was a fairly efficient caricaturist, more prolific in this line than George; but no genius. George, it appears, started in to draw vigorous and occasionally indecent political and social caricatures in a manner which suggested strongly the influence of Gillray. He became 'the clown in white gloves' working for the masses, specializing in brutal frankness. Even Gillray might have felt the Cruikshank *Life of Napoleon* went too far. George had a lively time in a riotous journal called *The Scourge*, which printed several caricatures which would be good for a term of imprisonment for criminal libel in our more tender days. He took the princesses' part against the Regent and gave it hot to Canning, Castlereagh, Bexley and Sidmouth. He had attracted considerable attention with a series of satires about the manners and customs of the Court when suddenly these ceased and the whole atmosphere of his work changed.

It was generally said – and not denied – that George's abandonment of the more downright kind of caricature was due to a tip he had received from Windsor Castle. True or not, a reaction had begun against 'coarseness' and it is probable that George, always obliging, found it both more

profitable – and congenial – to enter more genteel provinces of art. He became a book illustrator, at which his peculiar gifts of fancy caused him to be a great success, when he was not fighting his authors and quarrelling with his publishers – which happened constantly because of his theory that the illustrations should be drawn first at the unfettered discretion of the artist, the stories being written later to fit. From time to time the spirit of caricature gleamed, rather than shone, in his constant flow of quips about controversial topics; but finally it gave place almost completely to that of innocent fun about such subjects as the weather, sport, the fashions, the danger of travelling in 'these 'ere new-fangled railways', Christmas pudding and the like. It is by this phase of his work that Cruikshank is best remembered: for the rounded humour of his genial outlook upon the little things of everyday life, and for the true Cockney flavour of his fancy. The panorama he left of the manners and modes of his times are part of the historical records of Britain.

Inventions and Speculations

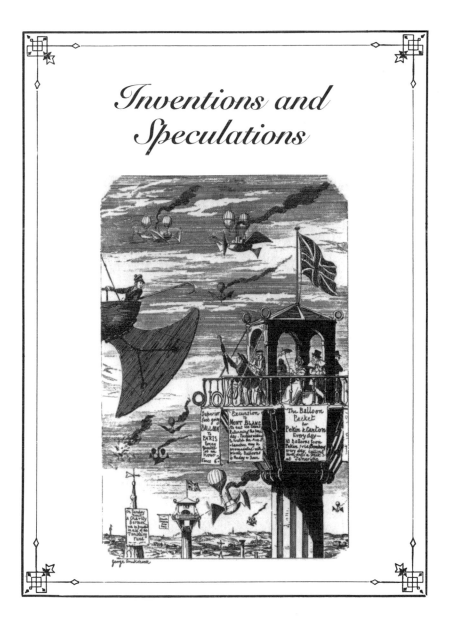

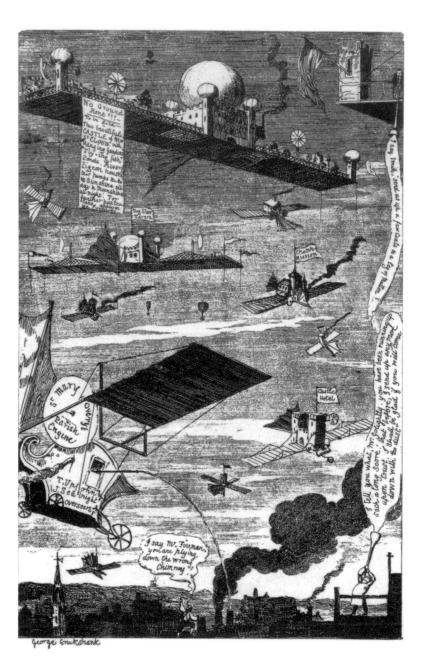

The Height of Speculation – Aerial Building

THE AERIAL
BUILDING COMPANY

A few gentlemen having taken the air for the purposes of building, have formed themselves into a Company, and are anxious to let in a limited number of the public. A surveyor, employed to survey the air, has reported that he sees nothing to obstruct the views of the Company. It is one of the peculiar advantages of this Association that there need be no outlay for land; and the great hope of success in this speculation arises from the fact that there is no ground for it. The Company will apply to Parliament for an Air Enclosure Bill, on the same principle as the proposed measure for shutting up Hampstead Heath; but, in the meantime, the treasurer will receive deposits on shares, and take premiums for air allotments. The intention of the Company is to form an Aerial City; and an architect has drawn plans, including sites for the various contemplated buildings, the whole of which buildings may be seen (on paper) at the Society's office, so that the sites may be at once secured and paid for.

The Company, not desiring to express any opinion as to the various contrivances for navigating the air proposed within the last few years, will leave it to the public to decide which principle it will be best to adopt, the Company declining to have anything to do with any principle whatever.

The Company, it must be understood, will convey the air under hand and seal; but the purchaser will have to convey the building. It is a desirable point in this speculation that there will be no tax for paving or lighting, there being no charge made by the Trustees of the Milky Way, nor is there any star-rate payable.

It is suggested that much may be done by parties willing to speculate in the air, when they are once comfortably settled there. Though it is true that the experiment of procuring sunbeams from cucumbers was never successfully carried out, the Aerial Building Company would hint the possibility of reversing this project, by getting cucumbers from sunbeams.

Further particulars may be had at the office in Air Street, where any questions may be asked; but, to save trouble, no answers will be given to any but *bonâ fide* shareholders. There are vacancies for a few clerks, who, on taking shares to the amount of £500, will receive 30s. a week for their services while the Company lasts, in addition to the usual dividend.

(*The Comic Almanack*, 1844)

SCIENCE UNDER
DIVERS FORMS

Letter from a Passenger on Board the Submarine Steamer

Well, here we are, safe and sound at the bottom of the Bay of Biscay, where we intend to sleep one night, for the purpose of testing the qualities of the bed of the ocean, which consists, as you will suppose, of several sheets of water, and plenty of wet blankets, with billows instead of pillows on the top of it.

Not being able to keep my head above water I determined on making a bold plunge, and therefore took my passage in the submarine steamer, where several others, who were, like myself, over head and ears, were anxious to keep out of the way, and having sunk all my available capital, I thought it better to sink myself by way of looking after it.

We have had a very delightful voyage, but we met on our way with some very odd fish, who stared rather rudely in at our cabin windows, and a party of lobsters looked exceedingly black as we passed very near to them. The mermaids were much alarmed at first, but soon became reconciled to our appearance, and, when we talked of weighing our anchor, they, with much simplicity, offered us the use of their scales.

You are aware that a company is forming for the purpose of turning the tide of emigration towards the bottom of the sea; and if people can live under water, they ought not, from mere motives of pride, to be above it. There will, of course, be some difficulty in dealing with the natives, but we have taken the precaution to treat with an influential oyster, who, however, keeps extremely close, and, if he will not manifest a little more openness, it is expected that war to the knife must be resorted to. We at first anticipated some hostility from the sharks, but, as we purposely abstained from bringing any lawyers among the first settlers, we have now very little fear of a collision on account of conflicting interests.

The appearance of our vessel has caused a considerable sensation among the inhabitants of the ocean, but we have followed the plan of the early emigrants to strange parts, and endeavoured to propitiate the various fish by trifling presents. We threw a box of antibilious pills to a large party of Cockles, and we pitched overboard a quantity of false collars to a group of salmon, whose gills seemed sadly out of condition. We also distributed copies of Crabbe and Shelley to as many of the crustaceous fish as approached near enough to our vessel to enable us to do so; while to a dog-fish we presented a fine specimen of bark, which he did not appear very much to relish. We met on our way down with one of the white sharks, which are known to be the terror of mariners. The creature stared at us with both its eyes, and, while

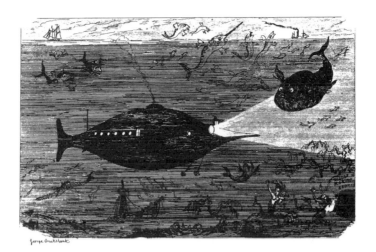

we maintained an awful silence, the shark seemed to respond to our muteness by holding its jaw in the most alarming manner: the extended cavity of its frightful mouth presented a harrowing exhibition, and it seemed as if, like other exhibitions, it might be 'open from ten to four', and then it would have been ten to one if we had escaped from being drawn into it. The tremendous teeth seemed clearly to indicate that there would be 'no admittance except on business', and we at length sheered off from sheer timidity.

If we can only manage to get up a colony down here, there will be plenty of patronage at our disposal; and if we are allowed the appointment of a bishop, where can there be a finer see than that which is here open to him? I have already issued prospectuses of a grand *Oceanic Agricultural Association*, to be established for the purpose of regularly ploughing the deep, and dividing the proceeds among the shareholders. I state, in my advertisement that, as we know the sea has produced sea-weed, we may reasonably expect that other vegetable matter may be reared, and as irrigation is the chief expense of agriculture, the saving in the article of water alone must keep the thing afloat – to say nothing of what will naturally flow into the coffers of the company.

I must now conclude my letter, for the vessel is about to start; and as 'tide and time wait for no man', you will perceive that I am so far tied to time as to be unable to add more than that I am

Your right down friend at the bottom,

DAVID DRINKWATER.

P.S. We have not yet visited the extensive locker of Davy Jones, Esquire, but we intend very shortly doing so.

(*The Comic Almanack*, 1843)

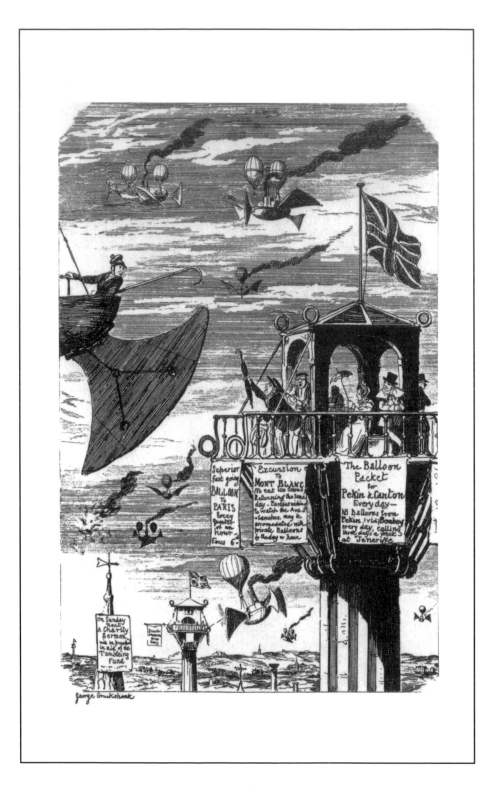

Superior
fast going
BALLOON
To
PARIS
Every
quarter
of an
hour!
Fare 6-

Excursion
To
MONT BLANC
To eat Ice Creams
Returning the same
day—Parties wishing
to watch the Ava-
-lanches, may be
accommodated with
private Balloons
by the day or hour

The Balloon
Packet
for
Pekin & Canton
Every day—
NB Balloons from
Pekin (via) Bombay
every day, calling
three days a week
at Teneriffe

On Sunday
next
A Charity
Sermon
will be preached
in aid of the
Tumbling
Fund

George Cruickshank

AIR-UM SCARE-UM TRAVELLING

'Who's for the excursion round the moon?
Here's the "Original Fly Balloon".'
 'Is it this that calls
 At the top of St Paul's,
Where I'm to take up my wife and babby?'
 'No, sir, it's not ours;
 We only touch at the towers
 Of Westminster Abbey.'

 We stop at the Great Bear,
 To take in air;
Then at once, without waiting at all, we fly on,
 In hopes of being in time to hear
 Some of the music of the sphere,
Accompanied by the band of Orion.
What a funny sensation it is the clouds to enter:
 Oh, don't you know the reason why
 You feel rather comic when up in the sky?
'Tis caused by your distance from gravity's centre.

But here's the Zodiac, where we dine,
The Bull or the Lion is the sign;
To stop at Aquarius does not answer,
But we call today at the Crab, if we *Can-sir*.
Here's a lawyer wants to be starting soon,
To watch the action of the moon;
A barrister wishes much to know
If a place is vacant, that he may go
To study the laws of the stars' rotation,
 With them keep pace,
 As they roll through space,
And join their circuit in the long vacation.

 The day of railways will be o'er,
 And steam will be esteem'd no more,
 When the result is seen
 Of the experiment of Mr. Green,
 Who says he can, as a matter of course,
 In a balloon the Atlantic cross;
 And, by way of proving he can,
 He shows us a part of his plan,
 Which looked, in miniature, very neat,
 At the Polytechnic in Regent Street,
 And answered, the truth to tell,
 Uncommonly well,
 As far as it went; but the fact to say,
 It went but a very little way.

No one could doubt the success of the notion,
If Hanover Square
One might compare
To the wide Atlantic Ocean.
It's a very fine thing,
To take hold of a string
Attached to a pretty toy balloon,
Guiding it easily either way,
And undertaking to say,
The Atlantic may be traversed soon,
By similar means;
Which will be credited by men
When all the world are Greens,
But not till then!

Modern Ballooning,
or the Newest Phase of Folly

PREMIUM

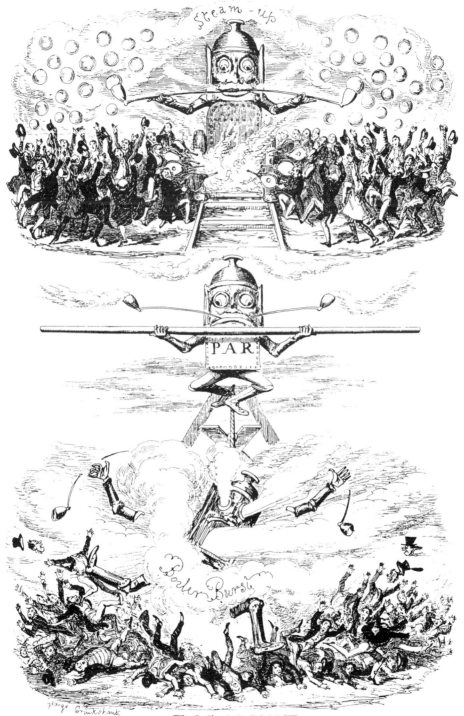

'Remembering Cruikshank'

(John Fowles, 1974)

Captain Frederick Marryat, the nautical novelist, visited Lyme Regis in the fall of 1819 and did some sketches that he passed on for 'improvement' to a friend. The friend's name was George Cruikshank. One of the results was a print that I shamelessly adapted for my novel *The French Lieutenant's Woman*. It shows a happy gentleman *voyeur* ensconced over a beach, telescope glued to his eye, and deeply absorbed in bird-watching – the birds in this case consisting of a charming batch of plumply naked Regency ladies tumbling and disporting themselves in the sea. 'Hydromania!' reads the legend, 'or a Touch of the Sub-Lyme and Beautiful' (1819) – a horrid pun on Edmund Burke's noble and unreadable *Philosophical Enquiry into . . . the Sublime and Beautiful* (1756). It shocked the worthy citizens of Lyme at the time and has gone on shocking them a little ever since; our definitive local history (published in 1927) feels obliged to pronounce the thing a tasteless lampoon without any historical basis at all. [. . .]

Of course 'illustrations by Cruikshank' still raises the price in every second-hand bookseller's catalogue, but fashion and taste seem adamantly to refuse him serious consideration. Bewick's reputation has done nothing but soar these last fifty years, [. . .] I have watched the prices of drawings by Tenniel, Leech, Keene and Du Maurier rise like rockets. Even to Cruikshank's own most immediate rival in the field of book illustration Hablot K. Browne ('Phiz'), history seems to have dealt a much kinder hand.

[. . .] To my mind Cruikshank is by far the greatest of the celebrated Victorian illustrators and cartoonists cited above. I suspect the runner-up is John Leech; but Leech never had Cruikshank's social concern, nor a quarter of his technical command – and then he was saddled by his unfortunate mania for the horse and the horsey. I can't consider Phiz as a serious rival. [. . .] Somewhere in Phiz was a soft centre, he could never in a thousand years have matched the bitter anger – as Cruikshank did so brilliantly – in the William Hone pamphlets. One has only to compare Phiz's plates for *Nickleby* and *David Copperfield* with Cruikshank's for

Oliver Twist and *Sketches by Boz* to see which man had more direct knowledge of reality – and resisted the schmaltz in Dickens more successfully. Try the two plates on rather similar themes by the two artists: 'Oliver asking for more' in *Twist* and 'The internal economy of Dotheboys Hall' in *Nickleby*. It is like comparing a Goya to a David.

Indeed, I think what is possibly Cruikshank's finest series of book illustrations, those for Maxwell's *History of the Irish Rebellion in 1798*, can be compared only to Goya. [. . .]

In his illustrations for another indifferent text – Ainsworth's *Jack Sheppard* – we see a further side of Cruikshank's mastery: his ability to create an indelible image. I never run across Sheppard's name without immediately evoking that white-faced young demon with his bizarrely ferocious eyebrows and jet-black Joan-of-Arc crewcut. Think of Fagin, Bill Sikes, the Artful Dodger: it is Cruikshank who has proved as inimitable as his author.

Needless to say, there were other Cruikshanks: the forerunner of Du Maurier, critic of middle-class foibles; the humorous vignettist; the temperance fanatic. All those aspects of his work bring him down to a lower level and perhaps define his essential weakness: too much humour, not enough anger – a very English combination. Chronologically, my genial little joke against Lyme must have been done between work on the cuts for the Hone pamphlets; and something I did not reveal at the beginning – the print copies to the point of plagiarism a previous jibe by Rowlandson against hydromania at Margate. To our authenticity-obsessed modern minds all this may seem a grave criticism of Cruikshank, indeed dangerously near make him guilty of the fault I have already laid at Phiz's door: a soft centre. But I don't think so: it simply shows his humanity and his breadth – if you like, the Augustan eighteenth century still triumphing over the narrower nineteenth.

We can see that breadth – of technique as well as of spirit – right down among the trivia: in the distinctly hasty yet vivid little drawings for *Sunday in London*, in the much more elaborate 'strip cartoon' series, *The Progress of Mr. Lambkin (The Bachelor's Own Book)*. In both there is a richness of observed detail and open honesty about the life portrayed. No Dr. Bowdler here, no Victorian prudery; but a full ration of the human heart.

I detect two great figures behind Cruikshank. The first is Hogarth, of course. Cruikshank never mastered oil, and given the age-old European award of primacy to that medium, I suppose he has to be placed on a lower pinnacle. But I suspect that if he and Hogarth had been Japanese, it might well have been the latter who now stood in the shade. Lists of artistic merit are strictly for fools, however, and the important thing is that these two English graphic masters did share, behind their personal neuroses, their particular exaggerations, an identity of spirit. They both attacked hypocrisy and anything that smelt of the complacent Establishment; more interested in man himself than in nature, they had the city in their blood; and for all their ruthless attacks on the stupidity and bestiality of *Homo Sapiens*, they never lost faith in his essential humanity.

Behind them again, a greater figure still, and not an artist – that arch destroyer of the puritanical and the illiberal, that founding father of the open society, that presiding spirit of both the Renaissance and our own century, François Rabelais. To be sure, he and Cruikshank would hardly have seen eye to eye over the divinity of the bottle. But I go back to my little print of Lyme, to the naked girls in the gentle September sea, to the delighted face of the watching man. The basic design may be stolen from Rowlandson, but it is far more than a mere copy. I still see in it the quintessence of Rabelais' smiling humanism, the *substantifique moëlle*, the real marrow of his gigantic comic bone.

Humour ought to be a religion; and Cruikshank, an honoured saint of that church.

The Pursuit
of Letters

Designed by George Cruikshank, to represent his highly esteemed and worthy friend, the late **Thomas Ingoldsby** Surrounded by some of the Characters, Good, Bad, & Indifferent, which he has so graphically portrayed in his celebrated **Legends**

Fellow, Richard Bentley

146

"The Age of Intellect."

The Grand "March of Intellect"

— Round Text & Small hand —

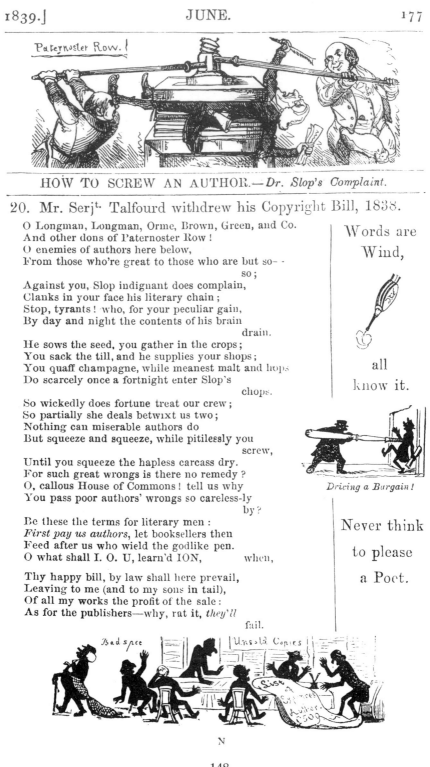

Paternoster Row!

HOW TO SCREW AN AUTHOR.—*Dr. Slop's Complaint.*

20. Mr. Serj.^t Talfourd withdrew his Copyright Bill, 1838.

O Longman, Longman, Orme, Brown, Green, and Co.
And other dons of Paternoster Row !
O enemies of authors here below,
From those who're great to those who are but so--
 so ;
Against you, Slop indignant does complain,
Clanks in your face his literary chain ;
Stop, tyrants ! who, for your peculiar gain,
By day and night the contents of his brain
 drain.

He sows the seed, you gather in the crops ;
You sack the till, and he supplies your shops ;
You quaff champagne, while meanest malt and hops
Do scarcely once a fortnight enter Slop's
 chops.

So wickedly does fortune treat our crew ;
So partially she deals betwixt us two ;
Nothing can miserable authors do
But squeeze and squeeze, while pitilessly you
 screw,
Until you squeeze the hapless carcass dry.
For such great wrongs is there no remedy ?
O, callous House of Commons ! tell us why
You pass poor authors' wrongs so careless-ly
 by ?

Be these the terms for literary men :
First pay us authors, let booksellers then
Feed after us who wield the godlike pen.
O what shall I. O. U, learn'd ION, when,

Thy happy bill, by law shall here prevail,
Leaving to me (and to my sons in tail),
Of all my works the profit of the sale :
As for the publishers—why, rat it, *they'll*
 fail.

Words are
Wind,

all
know it.

Driving a Bargain!

Never think

to please

a Poet.

Bad spee

Unsold Copies

N

148

The Sentimental Novel Reader

Abstraction

"The Pursuit of Letters" —

The Temptation of St. Anthony

A FABULOUS
CHARACTER

Being the Vulgar Notion of What is an Editor

An Editor is a privileged being whom superstition and the public have deified with mythological attributes, believing his existence to be nothing but one continual draught of milk and honey. We will not deny this at present, as we intend, 'just for the fun of the thing', to describe an Editor as he is believed by the imaginative public to be.

An Editor, then, according to that sapient authority, has the faculty of Jove or George Robins, as he has only to nod to knock down any object he pleases. He sleeps generally upon a bed of bank notes and roses, and is deprived of his rest if there happens to be the smallest crease in either. The bouquets thrown to Italian singers and French dancers, and the enormous profits realized by dwarfs and vegetable pills, never fail to supply him with a new mattress every night.

An Editor has a seat, of course, in the Cabinet Council, and dines about once a-week with the Minister, though his name never appears in print, but this is from ministerial policy, or a feeling of delicacy on his own part.

An Editor has a private box at every theatre, and as many at the Italian Opera as he chooses to ask for. On first nights he is waited on by the author or composer, who never leaves him without testifying his high admiration of his talents by a haunch of venison or a gold snuff-box. He has more influence behind the scenes than the manager himself.

An Editor is never happy but when he is making someone unhappy. The poets he slaughters, the managers he ruins, the members he kills with a 'pooh, pooh'; and the young men he crushes in the course of a day, would fill a Post Office Directory, or a Kensal Green Cemetery.

An Editor corresponds with every capital in the world. Emperors seek his advice, and even German princes are not too proud to court his alliance. An Editor's autograph always fetches more money than that of Shakespeare, Confucius, or Fieschi.

Of course an Editor never drinks anything but champagne, excepting soda-water in the morning, after some frightful orgie with a member of the aristocracy, these orgies being requisite twice a-week to keep up his editorial character.

An Editor lives in Mayfair, or Grosvenor Square. His library is furnished with presentation copies from every living author; and his rooms crowded with paintings and sculpture by the first artists of the day. He rides horses in the park that Centaur himself would envy.

The study of an Editor is a perfect study for giants in wealth and taste. It is a classic retreat for the mind, enriched with every possible stimulant for the body. Perfumes are burning there night and day. Gold and jewellery are lying in heaps like so much dust, on every shelf, and an air of oriental splendour is spread over everything from the bell-rope to the fire-tongs. There are genuine cigars from Havannah, real tumblers from Bohemia, and the finest screens from Japan. It is in this gorgeous study that the thousand-and-one charms which make the life of an Editor one long summer's walk through Elysium, bud and blossom around him; it is in this sanctuary that advertisers on their knees implore his aid, that publishers crouch before him, that members of Parliament and blacking-makers fawn with pheasants and Westphalia hams upon him, that authors and actors bring their golden tribute to him, too happy to kiss the hem of his *robe-de-chambre*.

An Editor dresses in the most Stultzo-Crœsus style; but no wonder! does he not always receive with both hands, and never pay with either? for it is very well known that he gets his boots, his coats, riding-whips, macassar, horses, and legs of mutton, all for nothing – merely for saying of the article in his paper, that 'it ought to be on every drawing-room table', or that 'not to know GIBLETT's kidneys argues yourself unknown'. And then if he wants a hundred-pound note, what process easier than to send a letter to Baron Schwindel of the Stock Exchange, enclosing a little article in print that is to appear in tomorrow's Number, intimating most strongly that the Baron is either a 'Bull' or a 'Bear', or perhaps both. This scheme always brings the required sum, and nothing is ever said about it afterwards.

But, unfortunately, an Editor, as he figures in real life, is quite a different creature to what he figures in a three-volume novel or

in the public's Arabian imagination. So let us in charity inform our readers what an Editor really is. He is then, reader, like yourself, merely a man, and not as you have gathered from fictions and reports, a Grand Junction of Rothschild and D'Orsay, with a branch of Doctor Johnson and Joseph Ady.

On the contrary, an Editor dresses plainly, keeps no stud beyond the one or two he wears in his shirt, pays the Income-tax with infinite grumbling when his salary allows him, but grumbles infinitely more when it does not; is as fond of champagne as any lady of fashion, but does not drink it so often as it costs eight shillings a bottle; sleeps on a mattress stuffed with more straw and thorns than roses; rarely violates the edicts of Father Mathew, and has no more victims than anyone else who has a tailor. And as for his playing Old Bogie to actors, filling the Bankruptcy Court with publishers, sending poets by dozens into Bedlam, and being waited on by a Prime Minister or a Prince Metternich, his name, ninety-nine cases out of a hundred, is not known by any one of them, and his influence does not extend beyond the office where his paper is printed, or the lodging he occupies in the neighbourhood of his printer's. The thousand and one charms, too, that colour and gild his existence, consist, in cold truth, in his devouring – no matter what his taste or appetite may be – a quantity of raw manuscripts; in answering questions about the colour of Prince Albert's hair; in being insulted by every other correspondent; in making an enemy for life of every contributor whose article he rejects; in being presented with 'the lie' by any member of the aristocracy for saying he has a cold when he has not; in being continually solicited to do miracles in his little paper which Parliament and the seven wise men could not effect; in being every other hour pestered for copy! – copy! – copy! and in stopping up to all hours of the morning in a cold printing-office correcting proofs.

Reader, unless you have had an University education, like hard work, have a soul for scissors and paste, are fond of reading the debates, are addicted to late hours, and are partial to illegible MS., every-day abuse, and rheumatisms, remain as you are, and abjure printers' devils as you would impatient creditors. The *romance* about an Editor may be very flattering and agreeable; but, believe us, so it ought to be, to compensate in any measure for the prosy *reality*!

(Horace Mayhew, *George Cruikshank's Table Book*, 1845)

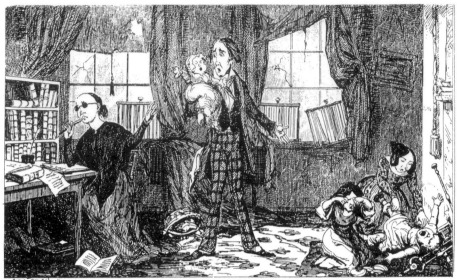

George Cruikshank

THE WOMAN OF MIND

My wife is a woman of mind,
 And Deville, who examined her bumps,
Vow'd that never were found in a woman
 Such large intellectual lumps.
'Ideality' big as an egg,
 With 'Causality' – great – was combined;
He charg'd me ten shillings, and said,
 'Sir, your wife is a woman of mind.'

She's too clever to care how she looks,
 And will horrid blue spectacles wear,
Not because she supposes they give her
 A fine intellectual air;
No! she pays no regard to appearance,
 And combs all her front hair behind,
Not because she is proud of her forehead,
 But because she's a woman of mind.

[. . .]

Whene'er she goes out to a dance,
 She refuses to join in the measure,
For dancing she can't but regard
 As an unintellectual pleasure:
So she gives herself up to enjoyments
 Of a more philosophical kind,
And picks all the people to pieces,
 Like a regular woman of mind.

154

She speaks of her favourite authors
 In terms far from pleasant to hear;
'Charles Dickens,' she vows, 'is a darling',
 'And Bulwer,' she says, 'is a dear',
'Douglas Jerrold', with her 'is an angel',
 And I'm an 'illiterate hind',
Upon whom her fine intellect's wasted;
 I'm not fit for a woman of mind.

She goes not to Church on a Sunday,
 Church is all very well in its way,
But she is too highly inform'd
 Not to know all the parson can say;
It does well enough for the servants,
 And was for poor people design'd;
But bless you! it's no good to her,
 For *she* is a woman of mind.

A Design for an ALBUM

"The Artist who gives up his time to Drawing in ALBUMS is like a midshipman upon half pay.. who gets "Nothing a day & finds himself"

'Cruikshank on Cruikshank'

(George Cruikshank, 1844–5)

MY PORTRAIT

I respectfully beg leave to assure all to whom 'My Portrait' shall come, that I am not now moved to its publication, for the first time, by any one of the ten thousand considerations that ordinarily influence modest men in presenting their 'counterfeit presentments' to the public gaze. Mine would possibly never have appeared at all, but for the opportunity thus afforded me of clearing up any mistakes that may have been originated by a pen-and-ink sketch which recently appeared in a publication entitled 'Portraits of Public Characters'.

The writer of that sketch was evidently animated by a spirit of kindness, and to kindness I am always sensitively alive; but he has been misinformed – he has represented me 'as I am not', instead of 'as I am'; and although it is by no means necessary that I should offer 'some account of myself' in print, it is desirable that I should, without fatiguing anybody, correct some half-dozen of the errors into which my biographer has fallen.

A few words of extract, and a few more of comment, and my object, as the moralist declares when he seeks to lure back *one* sinner to the paths of virtue, will be fully attained.

The sketch, which professes to be 'my portrait', opens thus: –

(1) 'I believe Geo. Cruikshank dislikes the name of *artist*, as being too common-place.'

I have my dislikes; but it happens that they always extend to things, and never settle upon mere names. He must be a simpleton indeed who dislikes the name of artist when he is not ashamed of his art. It is possible that I may once in my life, when 'very young', have said that I would rather carry a portmanteau than a portfolio through the streets and this, perhaps from a recollection of once bearing a copper-plate, not sufficiently concealed from the eyes of an observant public, under my arm, and provoking a salutation from a little ragged urchin, shouting at the top of his voice, hand to mouth – 'There goes a copper-plate engraver!' It is true, that as I walked on I experienced a sense of the uncomfortableness of that species of publicity,

Engraved by C.E. Wagstaff.

George Cruikshank [signature]

and felt that the eyes of Europe were very inconveniently directed to me; but I did not, even in that moment of mortification, feel ashamed of my calling: I did not 'dislike the name of artist'.

(2) 'When a very young man, it was doubtful whether the weakness of his eyes would not prove a barrier to his success as an artist.'

When a very young man, I was rather *short-sighted*, in more senses than one; but weak eyes I never had. The blessing of a strong and healthy vision has been mine from birth; and at any period of time since that event took place, I have been able, even with one eye, to see very clearly through a millstone, upon merely applying the single optic, right or left, to the centrical orifice perforated therein. But for the imputation of weakness in that particular, I never should have boasted of my capital eye; especially (as an aged punster suggests) when I am compelled to use the capital I so often in this article.

(3) 'The gallery in which George first studied his art, was, if the statement of the author of *Three Courses and a Dessert* may be depended on, the tap-room of a low public-house, in the dark, dirty, narrow lanes which branch off from one of the great thoroughfares towards the Thames. And where could he have found a more fitting place? where could he have met with more appropriate characters? – for the house was frequented, to the exclusion of everybody else, by Irish coal-heavers, hodmen, dustmen, scavengers, and so forth!'

I shall mention, *en passant*, that there are *no* Irish coal-heavers: I may mention, too, that the statement of the author adverted to is not to be depended on; were he living, I should show why. And now to the scene of my so-called 'first studies'. There was, in the neighbourhood in which I resided, a low public-house; it has since degenerated into a gin-palace. It was frequented by coal-heavers only, and it stood in Wilderness-lane (I like to be particular), between Primrose-hill and Dorset-street, Salisbury-square, Fleet-street. To this house of inelegant resort (the sign was starting, the 'Lion in the Wood'), which I regularly passed in my way to and from the Temple, my attention was one night especially attracted, by the sounds of a fiddle, together with other indications of festivity; when, glancing towards the tap-room window, I could plainly discern a small bust of Shakespeare placed over the chimney-piece, with a short pipe stuck in its mouth, thus –

This was not clothing the palpable and the familiar with golden exhalations from the dawn, but it was reducing the glorious and immortal beauty of Apollo himself to a level with the common-place and the vulgar. Yet there was something not to be quarrelled with in the association of ideas to which that object led. It struck me to be the perfection of the human picturesque. It was a palpable meeting of the Sublime and the Ridiculous, the world of Intellect and Poetry seemed thrown open to the meanest capacity; extremes had met; the highest and the lowest had united in harmonious fellowship. I thought of what the great poet had himself been, of the parts that he had played, and the wonders he had wrought, within a stone's throw of that very spot; and feeling that even he might have well wished to be there, the pleased spectator of that lower world, it was impossible not to recognize the fitness of the pipe. It was the only pipe that would have become the mouth of a poet in that extraordinary scene; and without it, he himself would have wanted majesty and the right to be present. I fancied that Sir Walter Raleigh might have filled it for him. And *what* a scene was that to preside over and to contemplate! What a picture of life was there! It was as though Death were dead! It was *all* life. In simpler words, I saw, on approaching the window and peeping between the short red curtains, a swarm of jolly coal-heavers! Coal-heavers all – save a few of the fairer and softer sex – the wives of some of them – all enjoying the hour with an intensity not to be disputed, and in a manner singularly characteristic of the tastes and propensities of aristocratic and fashionable society; – that is to say, they were 'dancing and taking refreshments'. They only did what 'their betters' were doing elsewhere. The living Shakespeare, had he been, indeed, in the presence, would but have seen a common humanity working out its objects, and have felt that the *omega*, though the last in the alphabet, has an astonishing sympathy with the *alpha* that stands first.

This incident, may I be permitted to say, led me to study the characters of that particular class of society, and laid the foundation of scenes afterwards published. The locality and the characters were different, the spirit was the same. Was I, therefore, what the statement I have quoted would lead anybody to infer I was, the companion of dustmen, hodmen, coalheavers, and scavengers? I leave out the 'and so forth' as superfluous. It would be just as fair to assume that Morland was the companion of pigs, that Liston was the associate of louts and footmen, or that Fielding lived in fraternal intimacy with Jonathan Wild.

(4) 'With Mr. Hone' (afterwards designated 'the most noted infidel of his day') 'he had long been on terms not only of intimacy, but of warm friendship.'

A very select class of associates to be assigned to an inoffensive artist by a friendly biographer: coal-heavers, hodmen, dustmen and scavengers for my companions, and the most noted infidel of his day for my intimate friend! What Mr. Hone's religious creed may have been at that time, I am far from being able to decide; I was too young to know more than that he seemed deeply read in theological questions, and, although unsettled in his opinions, always professed to be a Christian. I knew also that his conduct was regulated by the strictest morality. He had been brought up to detest the Church of Rome, and to look upon the 'Church of England' service as little better than popish ceremonies; and with this feeling, he parodied some portions of the Church service for purposes of political satire. But with these publications *I had nothing whatever to do*; and the instant I heard of their appearance, I entreated him to withdraw them. That I was his friend, is true; and it is true, also, that among his friends were many persons, not more admired for their literary genius, than esteemed for their zeal in behalf of religion and morals.

(5) 'Not only is George a decided liberal, but his liberalism has with him all the authority of a moral law.'

I have already said, that I never quarrel with names, but with things; yet as so many and such opposite interpretations of the terms quoted are afloat, and as some of them are not very intelligible, I wish explicitly to enter my protest against every reading of the word 'liberal', as applicable to me, save that which I find attributed to it in an old and seemingly forgotten dictionary – 'Becoming a gentleman, generous, not mean.'

(6) 'Even on any terms his genius could not, for some time past, be said to have been marketable, Mr. Bentley the bookseller having contrived to monopolize his professional labours for publications with which he is connected.'

This assertion was to a certain extent true, while I was illustrating *Oliver Twist* and *Jack Sheppard*, works to which I devoted my best exertions; but so far from effecting a monopoly of my labours, the publisher in question has not for a twelvemonth past had from me more than a single plate for his monthly *Miscellany*; nor will he ever have more than that single plate per month; nor shall I ever illustrate any other work that he may publish.

(7) 'He sometimes sits at his window to see the patrons of "Vite Condick Ouse" on their way to that well-known locality on Sundays,' &c.

As my 'extraordinary memory' is afterwards defined to be 'something resembling a supernatural gift', it ought to enable me to recollect this habit of mine; yet I should have deemed myself as innocent of such a mode of spending the Sabbath as Sir Andrew Agnew himself, but for this extraordinary discovery. I am said to have 'the most vivid remembrance of anything droll or ludicrous'; and yet I cannot remember sitting at the window 'on a Sunday' to survey the motley multitude strolling towards 'Vite Condick Ouse'. I wish the invisible girl would sell me her secret.

(8) 'He is a very singular, and, in some respects, eccentric man, considered, as what he himself would call, a "social being". The ludicrous and extraordinary fancies with which his mind is constantly teeming often impart a sort of wildness to his look, and peculiarity to his manner, which would suffice to *frighten from his presence* those unacquainted with him. He is often so uncourteous and abrupt in his manner as to incur the charge of seeming rudeness.'

Though unaccustomed to spend the Sabbath day in the manner here indicated, I have never yet been regarded as *Saint George*; neither, on the other hand, have I ever before been represented as the Dragon! Time was, when the dove was not more gentle; but now I 'frighten people from my presence', and the isle from its propriety. The 'Saracen's Head' is all suavity and seductiveness compared to mine. Forty thousand knockers, with all their quantity of fright, would not make up my sum. I enter a drawing-room, it may be supposed, like one prepared to go the whole griffin. Gorgons, and monsters, and chimeras dire, are concentrated by multitudes in my person.

The aspect of Miss Jemima Jones, who is enchanting the assembled party with 'See the Conquering Hero Comes', instantaneously assumes the expression of a person singing 'Monster Away'. All London [. . .] is terror-stricken wherever I go. I am as uncourteous as a gust of wind, as abrupt as a flash of lightning, and as rude as the billows of the sea. But of all this, be it known that I am 'unconscious'. This is acknowledged; 'he is himself unconscious of this', which is true to the very letter, and very sweet it is to light at last upon an entire and perfect fact. But enjoying this happy unconsciousness – sharing it moreover with my friends why wake me from the delusion! Why excite my imagination, and unstring my nerves, with visions of nursery-maids flying before me in my suburban walks – of tender innocents in arms frightened into fits at my approach, of five-bottle men turning pale in my presence, of banquet-halls deserted on my entrance!

(9) 'G. C. is the only man I know moving in a respectable sphere of life who is a match for the under class of cabmen. He meets them on their own ground, and fights them with their own weapons. The moment they begin to swagger, to bluster, and abuse, he darts a *look* at them, which, in two cases out of three, has the effect of reducing them to a tolerable state of civility; but if looks do not produce the desired results – if the eyes do not operate like oil thrown on the troubled waters, he talks to them in tones which, aided as his words and lungs are by the fire and fury darting from his eye, and the vehemence of his gesticulation, silence poor John effectually,' &c.

Fact is told in fewer words than fiction. It so happens that I never had a dispute with a cabman in my life, possibly because I never provoked one! From me they are sure of a civil word; I generally open the door to let myself in, and always to let myself out; nay, unless they are very active indeed, I hand the money to them on the box, and shut the door to save them the trouble of descending. 'The greatest is behind' – *I invariably pay them more than their fare*; and frequently, by the exercise of a generous forgetfulness, make them a present of an umbrella, a pair of gloves, or a handkerchief. At times, I have gone so far as to leave them a few sketches, as an inspection of the albums of their wives and daughters (they *have* their albums doubtless) would abundantly testify.

(10) 'And yet he *can* make himself exceedingly agreeable both in conversation and manners when he is in the humour so to do. I have met with persons who have been loaded with his civilities and attention. I *know* instances in which he has spent considerable time in showing strangers everything curious in the house; he is a collector of curiosities.'

No single symp . . . – I was about to say that no single symptom of a curiosity, however insignificant, is visible in my dwelling, when by audible tokens I was (or rather am) rendered sensible of the existence of a *pair of*

bellows. Well, in these it must be admitted that we *do* possess a curiosity. We call them 'bellows', because, on a close inspection, they appear to bear a much stronger resemblance to 'bellows' than to any other species of domestic implement; but what in reality they are, the next annual meeting of the great Scientific Association must determine; or the public may decide for themselves when admitted hereafter to view the precious deposit in the British Museum. In the mean time, I vainly essay to picture the unpicturable.

Eccentric, noseless, broken-winded, dilapidated, but immortal, these bellows have been condemned to be burnt a thousand times at least; but they are bellows of such an obstinate turn of mind that to destroy them is impossible. No matter how imperative the order – how immediate the hour of sacrifice, they are sure to escape. So much for old maxims; we may 'sing old Rose', but we cannot 'burn the bellows'. As often as a family accident happens – such as the arrival of a new servant, or the sudden necessity for rekindling an expiring fire, out come *the* bellows, and forth go into the most secret and silent corners of the house such sounds of wheezing, squeaking, groaning, screaming, and sighing, as might be heard in a louder, but not more intolerable key, beneath the roaring fires of Etna. Then, rising above these mingled notes, issues the rapid ringing of two bells at once, succeeded by a stern injunction to the startled domestic 'never on any account to use those bellows again', but on the contrary, to burn, eject and destroy them without reservation or remorse. One might as well issue orders to burn the east wind. A magic more powerful even than womanly tenderness preserves them; and six weeks afterwards forth rolls once more that world of wondrous noises. Let no one imagine that I have really sketched the bellows, unless I had sketched their multitudinous *voice*. What I have felt when drawing Punch is, that it was easy to represent his eyes, his nose, his mouth; but that the one essential was after all wanting — the *squeak*. The musician who undertook to convey by a single sound a sense of the peculiar smell of the shape of a drum, could alone picture to the *eye* the howlings and whisperings of the preternatural bellows. Now you hear a moaning as of one put to the torture, and may detect both the motion of the engine and the cracking of the joints; anon cometh a sound as of an old beldame, half inebriated, coughing and chuckling. A sigh as from the depths of a woman's heart torn with love, or the 'lover sighing like furnace', succeeds to this; and presently break out altogether – each separate note of the straining pack struggling to be foremost – the yelping of a cur, the bellowing of a schoolboy, the tones of a cracked flute played by a learner, the grinding of notched knives, the slow ringing of a muffled muffin-bell, the interrupted rush of water down a leaky pipe, the motion of

a pendulum that does not know its own mind, the creaking of a prison-door, and the voice of one who crieth the last dying speech and confession; together with fifty thousand similar sounds, each as pleasant to the ear as 'When am I to have the eighteen-pence' would be, to a man who never had a shilling since the day he was breeched. The origin of the bellows, I know not; but a suspicion has seized me that they might have been employed in the Ark had there been a kitchen fire there; and they may have assisted in raising a flame under the first tea-kettle put on to celebrate the laying of the first stone of the Great Wall of China. They are ages upon ages older than the bellows of Simple Simon's mother; and were they by him to be ripped open, they could not possibly be deteriorated in quality. The bellows which yet bear the inscription,

> Who rides on these bellows?
> The prince of good fellows
> Willy Shakespeare,

are a thing of yesterday beside these, which look as if they had been industriously exercised by some energetic Greek in fanning the earliest flame of Troy. To descend to later days, they must have invigorated the blaze at which Tobias Shandy lighted his undying pipe, and kindled a generous blaze under that hashed mutton which has rendered Amelia immortal. But 'the days are gone when beauty bright' followed quick upon the breath of the bellows: their effect at present is, to give the fir[e] [a] bad cold; they blow an influenza into the grate. Empires rise and fall, and a century hence the bellows may be as good as new. Like puffing, they will know no end.

(11) And lastly – for the personality of this paragraph warns me to conclude – 'In person G. C. is about the middle height and proportionately made. His complexion is something between *pale* and *clear*; and his hair, which is tolerably ample, *partakes* of a *lightish hue*. His face is of the angular form, and his forehead has a *prominently receding* shape.'

As Hamlet said to the ghost, I'll go no further! The indefinite complexion, and the hair 'partaking' of an opposite hue to the real one, may be borne; but I stand, not upon my head, but on my forehead! To a man who has once passed the Rubicon in having dared to publish his portrait, the exhibition of his mere profile can do no more injury than a petty larceny would after the perpetration of a highway robbery. But why be tempted to show, by an outline, that my forehead is innocent of a shape (the 'prominently receding' one) that never yet was visible in nature or in art? Let it pass, till it can be explained.

'He delights in a handsome pair of whiskers.' Nero had one flower flung upon his tomb. 'He has somewhat of a dandified appearance.' Flowers soon fade, and are cut down; and this is the 'unkindest cut of all'. I who, humbly co-operating with the press, have helped to give permanence to the name of dandy – I who have all my life been breaking butterflies upon wheels in warning against dandyism and dandies – am at last discovered to be 'somewhat' of a dandy myself.

> Come Antony, and young Octavius, come!
> Revenge yourselves –

as you may – but, dandies all, I have not done with you yet. To resume. 'He used to be exceedingly partial to Hessian boots.' I confess to the boots; but it was when they were worn even by men who walked on loggats. I had legs. Besides, I was very young, and merely put on my boots to *follow* the fashion. 'His age, if his looks be not deceptive, is *somewhere between* forty-three and forty-five.' A very obscure and elaborated mode of insinuating that I am forty-*four*. 'Somewhere between!' The truth is – though nothing but extreme provocation should induce me to proclaim even truth when age is concerned – that I am 'somewhere between' twenty-seven and sixty-three, or I may say sixty-four – but I hate exaggeration.

Exit, G. Ck.

(*George Cruikshank's Omnibus*, 1841–2)

THE UNEXHIBITED CARTOON OF GUY FAWKES

Having been advised by my friends to publish a sketch of my cartoon, intended for exhibition at Westminster Hall, I think the public, upon seeing it, will require some explanation of it. The subject has often been treated, and sometimes rather ill-treated, by preceding artists. Being forcibly struck by the grand classical style, I have aimed at it, and I trust I have succeeded in hitting it. At all events, if I have not quite come up to the mark, I have had a good bold fling at it.

The first thing I thought it necessary to think of [. . .] was to get a faithful portrait of the principal character. For that purpose I determined to study nature, and strolled about London and the suburbs on the 5th November, in search of a likeness of Fawkes, caring little under what Guys it might be presented to me. Unfortunately, some had long noses and some had short, so, putting this and that together, the long and the short of it is, that I determined on adopting a living prototype, who has been blowing up both Houses of Parliament for several years, and if not a Fawkes in other respects, is at least famous for encouraging forking out on the part of others.

Having got over the preliminary difficulty, I set to work upon my cartoon: and being resolved to make it a greater work than had ever before been known, I forgot the prescribed size, for my head was far above the consideration of mere feet, and I did not reflect, that where Parliament had

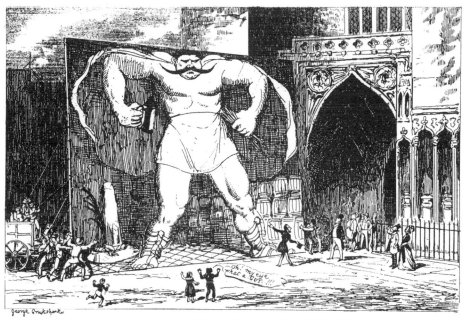

Guy Fawkes Treated Classically – An Unexhibited Cartoon

given an inch I was taking an ell, at the very lowest estimate. Having strolled towards Westminster Hall to survey the scene of my future triumphs, it struck me that I had carried the grand classical to such a height as to preclude all chance of my cartoon being got in through the doorway: and I, therefore, with the promptitude of a Richard the Third, determined to 'Off with his head', by taking a slice off the top of the canvass. This necessary piece of execution rather spoiled the design, but it enabled me to throw a heaviness into the brows of my principal figure, which, if it marred the resemblance to Fawkes, gave him an additional look of the Guy, at all events. It then occurred to me that I might further diminish the dimensions by taking a couple of feet off the legs; and this happy idea enabled me to carry out the historical notion that Fawkes was the mere tool of others, in which case, to cramp him in the understanding must be considered a nice blending of the false in art with the true in nature. The Guy's feet were accordingly foreshortened, till I left him, as he appeared when trying to defend himself at his trial, with hardly a leg to stand upon. Besides I knew I could fresco out his calves in fine style, when I once got permission to turn the fruit of my labours into wall-fruit, on the inside of the Houses of Parliament.

It will now be naturally asked, why my cartoon was not exhibited with others, some of [which] were equally monstrous, in the Hall of Westminster. The fact is, if the truth must out, the cartoon would not go in. Though I had cramped my genius already to suit the views of the Commissioners, and the size of the door, I found I must have stooped much

lower if I had resolved on finding admittance for my work. I wrote at once [. . .] calling upon them to widen the door for genius, by taking down a portion of the wall: but it will hardly be believed, that though there were, at the time, plenty of workmen about the building, no answer was returned to my request. [. . .]

It will be seen that the arch conspirator – for so I must continue to call him, though he could not be got into the archway – has placed his hat upon the ground, a little point in which I have blended imagination with history, and both with convenience. The imagination suggests that such a villain ought not to wear his hat; history does not say that he did, which is as much as to hint that he didn't; while convenience coming to the aid of both, renders it necessary for his hat to lie upon the ground, for if I had tried to place it on his head, there would have been no room for it. There was one gratifying circumstance connected with this cartoon which, in spite of my being charged with vanity, I must repeat. As it was carried through the streets it seemed to be generally understood and appreciated, everyone, even children, exclaiming as it passed, 'Oh! there's a Guy!'

(*The Comic Almanack*, 1844)

Scraps and Sketches

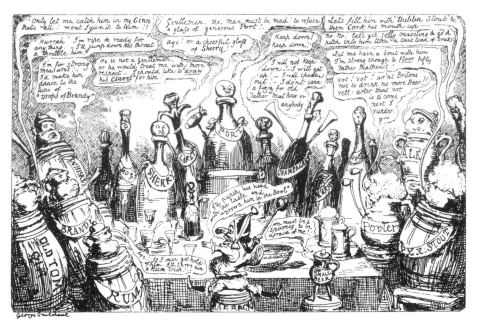

Wine in a Ferment and Spirits in Hot Water

THE PRAISE OF PUNCH

I love thee, Punch! with all thy faults and failings,
Spite of the strait-laced folks and all their railings;
 I love thee in thy state *etherial*,
Thou grateful compound of strange contradictions!
Filling the brain with Fancy's vivid fictions:
 Thou castle-building wight!
 Urging imagination's airy flight;
 Chasing blue devils from their dismal revels;
Spurning this sombre world of selfish sadness,
And changing sounds of woe to notes of gladness:
 Call'd by whatever name,
Rum, Rack, or Toddy, – thou soul without a body!
 Thy welcome is the same.

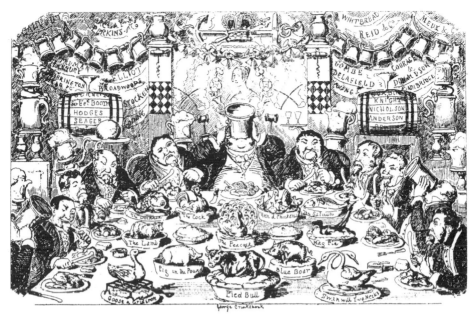

The Unlicensed Victuallers' Dinner

'Ha! That's something like a mutton chop!'

A jolly companion —

169

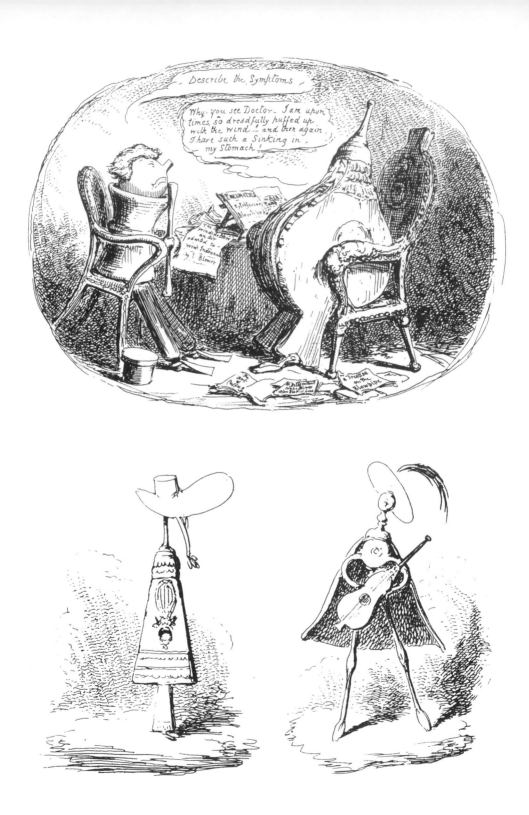

Puffing a Grate Singer

— O! we are the fellows —
To sing old Rose & burn the bellows.

171

FRIGHTFUL STATE OF THINGS,

IF FEMALE AGITATION IS ALLOWED ONLY FOR A MINUTE.

THE standard of rebellion is first raised at a fashionable tea-party.

The rebels rush into the street, break open the public-houses, and ask the men if they are not ashamed of themselves to be sitting there, whilst their poor dear wives are crying their eyes out at home?

Clubs are put down and a Petticoat Government proclaimed.

Armed patrols parade the streets, and take up every good-for-nothing husband that is found out after nine o'clock.
Total abolition of latch-keys.

All men proved to be "brutes," are taken to business in the morning by the Nurse, and fetched home at night by the Cook

Those who offer the slightest resistance are put to mend their wives' stockings.

The greatest reprobates are sentenced to sit up for their dear wives

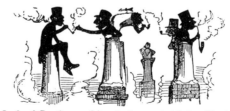

The Lords of Creation are driven to the greatest extremities to enjoy a quiet pipe.

But if detected, they are immediately made public examples of, by being sent out to air the babies

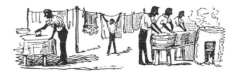

Those who resist the strong arm of the sex are immediately sent to the House of Correction, and put for fourteen days upon dirty linen.

If detected a second time, they are sentenced to a month's imprisonment, and hard labour at the mangle.

The most refractory are condemned to cold meat for life, without benefit of pickles.

The heartless ringleader is loaded with irons.

A member of the Royal Family only saves himself with a fine of twelve dozen bright pokers, and an Exchequer bond for one hundred steel fenders!

But human patience can endure it no longer, and the poor convicts endeavour to elude the vigilance of the watch, by smuggling themselves out amongst the clean linen.

The secret, however, is accidentally divulged by a criminal of great weight, who drops through the fragile clothes-basket.

The wretched criminals are carried away by the overpowering force of "Woman's Mission," and their precipitate folly only ends in their being floored at the bottom of the stairs, where, in aching shame, they lie and bite the dust.

Five thousand helpless husbands, whose only crime is their unfortunate sex, are incarcerated in the Thames Tunnel! Not a glass of grog, or a newspaper, or a cigar is allowed them!!

Hundreds perish daily for the want of the common necessaries of life!!!

The Black Hole is beaten hollow !!!!

Frightful rush, and tremendous overflow in the Thames Tunnel, through an insane attempt of the Boy Jones to escape by the roof !!!!!

Those who are not drowned, go mad.

An armistice takes place between the opposing bodies. A member of the Coburg family offers his hand to Mrs. Gamp, but is indignantly rejected by the lovely widow.

The body of the "oldest inhabitant" is found at Herne Bay, where it is supposed he emigrated for safety.

There is not a single man left, excepting the Man in the Moon.

The ladies, being left to themselves, proceed to discuss their wrongs, when, after several years' arguments, the world is graced with

THE FEMALE MILLENNIUM.

This continues thirty years, when the argument is decided at length in favour of

THE LAST WOMAN,

Who compodges herself in honour of the occasion a nice dish of tea, and after propodging a toast to the memory of that blessed creature Mrs. Harris dies universally "regretted" on the throne of Buckingham Palace.

———

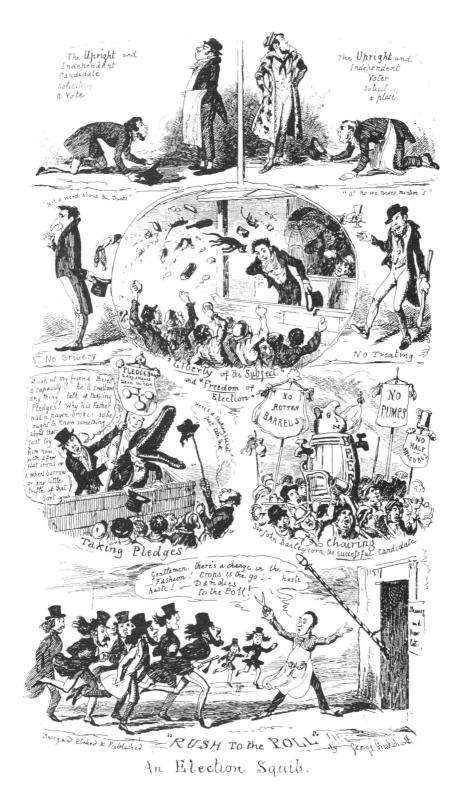

An Election Squib.

Ugly Customers

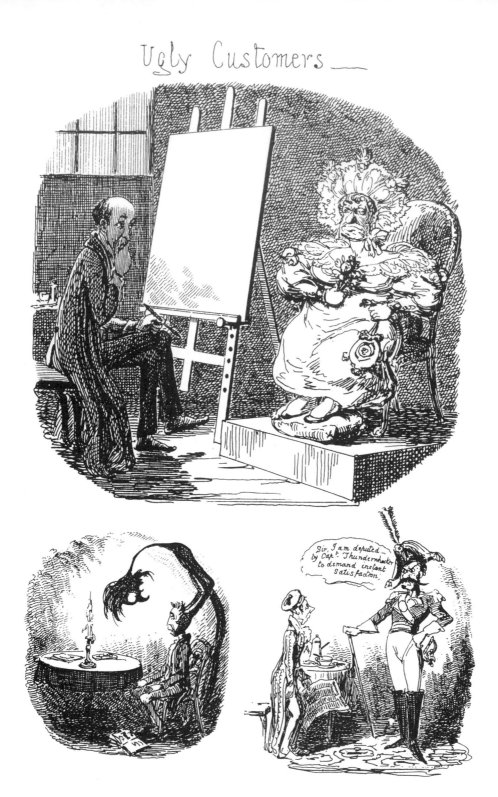

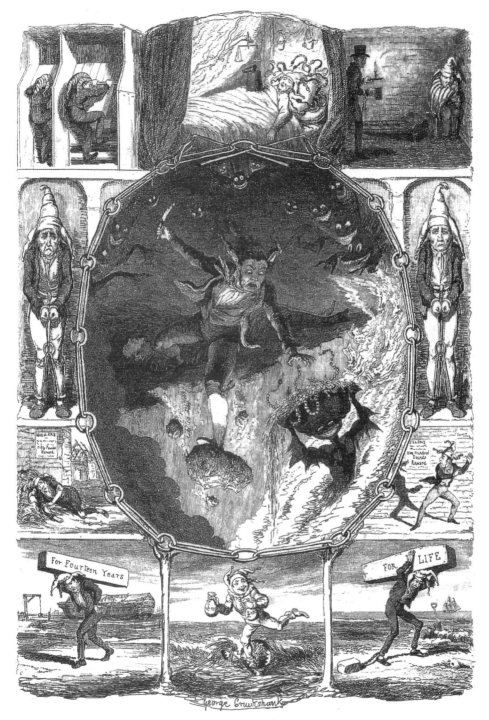

The Folly of Crime.

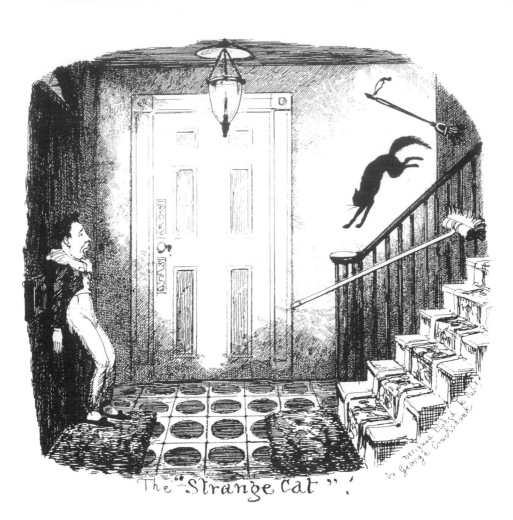

The "Strange Cat"!

Designed Etched & Published by George Cruikshank

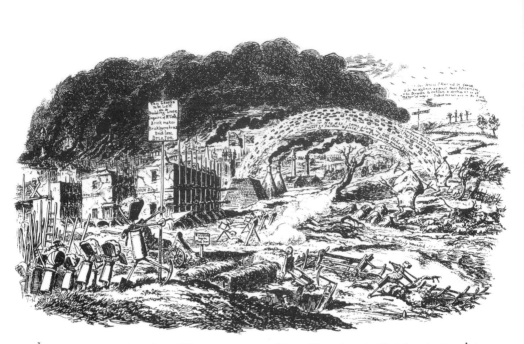

LONDON going out of Town. — or — The March of Bricks & Mortar.

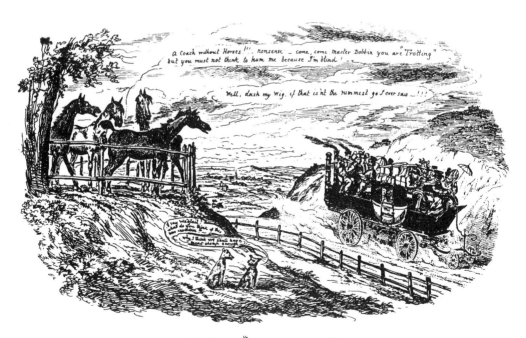

The Horses, "going to the Dogs" —

Oh! my goodneſs there is a mouse !!!

Oh! my good gracious! here is a great
"Black Beadle" !.!! !!!

Flying — Beadles

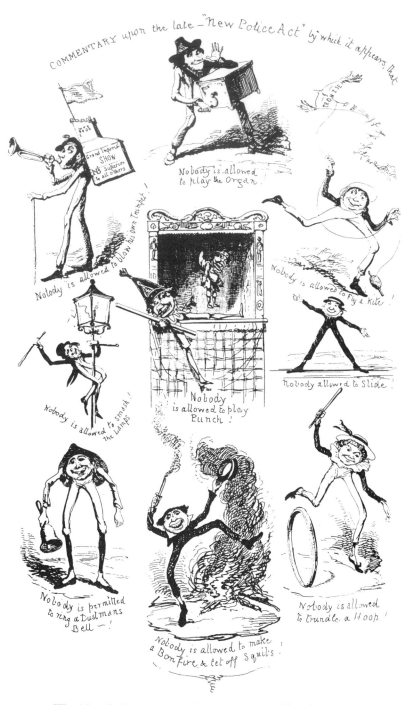

(The New Police Act of 1841 ruled that drinking-houses must shut by midnight on Saturdays – Cruikshank speculates on what other absurdities the law might stretch to. [Ed.])

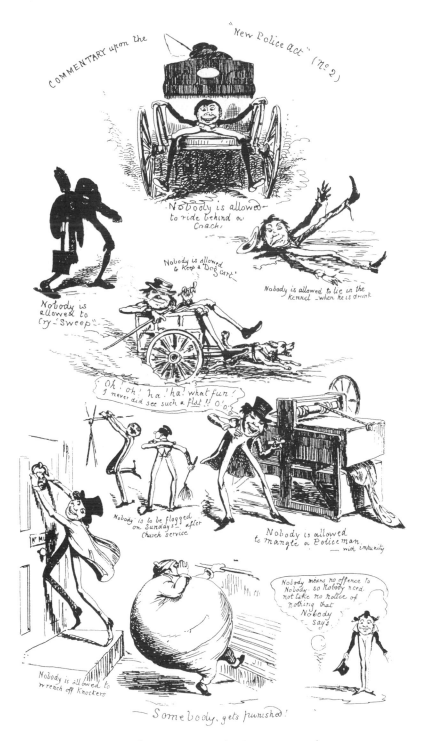

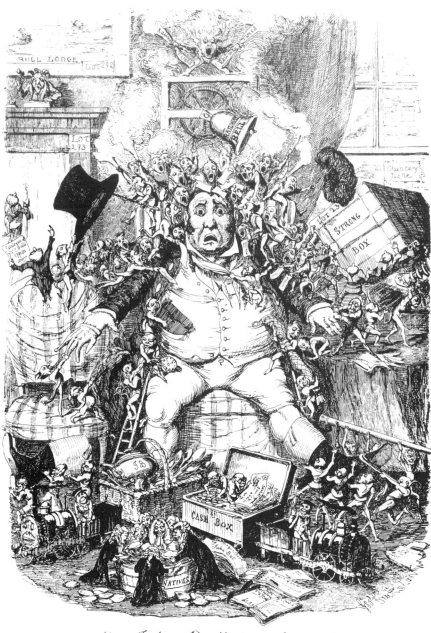

Mr. John Bull in a Quandary,
or
The anticipated effects of the Railway calls.

The Railway Dragon.

(*Omnibus* illustrations depicting public fear of the collapse of
bubble companies involved with the privately run railway
network [Ed.])

Nobody made fun of —

Nobody, desires the Painter to make
him as Ugly and as ridiculous as possible —

Language

PRACTICAL MESMERISM

A Gentleman in a Coma

Relieving a Gentleman from a State of Coma

Clairvoyant Coast Guards

The Height of Impudence

The Atheist

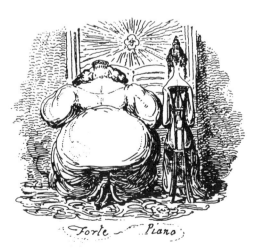

Forte — Piano

A Vane man

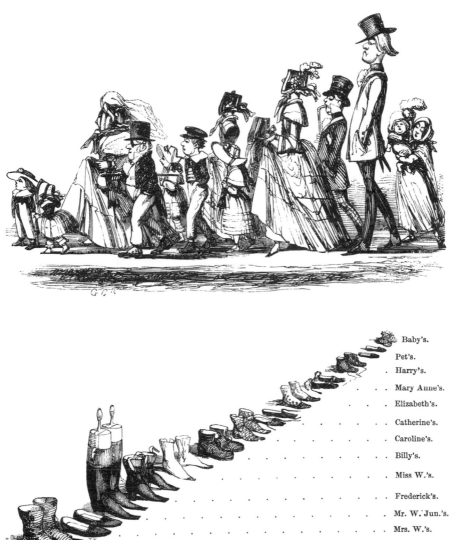

> Baby's.
> Pet's.
> Harry's.
> Mary Anne's.
> Elizabeth's.
> Catherine's.
> Caroline's.
> Billy's.
> Miss W.'s.
> Frederick's.
> Mr. W. Jun.'s.
> Mrs. W.'s.
> and My Own ! "

Latitude & Longitude

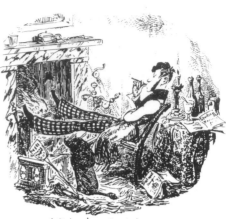

A Batchelors Comforts
(i e) enjoying both sides of the fire place

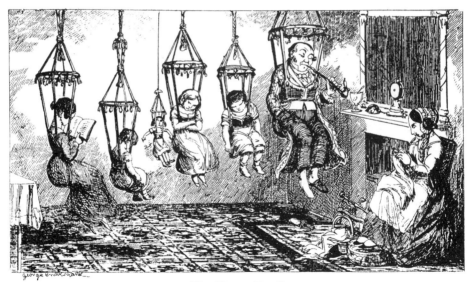

The Happy Family
'A Quiet Hint to the Wives of England'

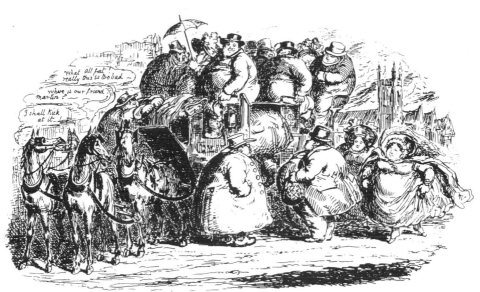

Just room for three insides Sir

Lumber-Troopers

PICTURE SOURCES

Page 1 *George Cruikshank's Omnibus* (1841–2) (*GCO*); frontispiece *George Cruikshank's Table Book* (1845) (*GCTB*); title page *My Sketchbook* (1833–6) (*MS*); p. 4 *GCO*; p. 6 *GCO*; p. 8 *The Comic Almanack* (1851) (*CA*); pp. 10–34 (sources given); p. 36 *The Hornet* (1871); p. 37 *CA* (1845); p. 38 *CA* (1837); p. 39 (top) *CA* (1837), (bottom) *Scraps and Sketches* (1828–32) (*SS*); p. 40 *CA* (top, 1835, bottom, 1837); p. 41 *CA* (1846); p. 42 *CA* (1841); p. 43 *GCO*; p. 44 *CA* (top, 1844; bottom, 1846); p. 45 *CA* (top, 1844, bottom 1846); p. 46 *CA* (1846); p. 47 *CA* (1837); p. 48 *MS*; p. 49 *CA* (1846); p. 50 *CA* (1838); p. 51 *CA* (1841); pp. 52–85 (sources given); p. 86 *SS*; p. 89 *GCTB*; pp. 90–1 (top) (produced as prints); p. 91 (bottom) *SS*; p. 92 *CA* (top 1850, bottom 1853); p. 93 *CA* (details) (1852); p. 94 (top) *CA* (1850), (others) *SS*; p. 95 *A Comic Alphabet* (1836); pp. 97–115 (sources given); p. 119 *MS*; p. 120 (top) *CA* (1851), (bottom) *MS*; pp. 121–5 (sources given); p. 126 (top) *MS*, (bottom) *SS*; p. 127 *MS*; p. 128 *CA* (top, 1847, bottom 1841); p. 129 *SS*; p. 130 (top) *SS*, (others) *MS*; p. 133 *CA* (1843); p. 134 *CA* (1844); p. 137 *CA* (1843); p. 138 *CA* (1843); p. 140 *CA* (1851); p. 141 *GCTB*; p. 145 *GCTB*; p. 146 R.H. Barham *The Ingoldsby Legends* (1870 edition); p. 147 *SS*; p. 148 *CA* (1849); p. 149 (top) (source unknown), (bottom) *MS*, (right) *GCTB*; p. 150 (top) *SS*, (bottom) (source unknown); pp. 152–3 (source given); p. 154 *CA* (1847); p. 155 *MS*; pp. 156–66 (sources given); p. 167 *MS*; p. 168 (top) *CA* (1836), (bottom) *GCTB*; p. 169 (top) *CA* 1841, (centre) *GCTB*, (bottom) *SS*; pp. 170–1 *SS*; pp. 172–4 *CA* (1849); p. 175 *GCO*; p. 176 *MS*; p. 177 *GCTB*; p. 178 *GCO*; p. 179 (top) *GCO*, (bottom) *GCTB*; p. 180 *SS*; p. 181 *GCO*; pp. 182–3 *GCO*; pp. 184–5 *GCTE*; p. 186 (top) *SS*, (bottom) *Phrenological Illustrations* (1826); p. 187 *GCTB*; p. 188 (top left) *GCO*, (top right) *MS*, (bottom, left and right) *SS*; p. 189 *GCTB*; p. 190 (top left) *A Comic Alphabet*, (top right) *SS*, (bottom) *CA* (1849); p. 191 (top) *SS* (bottom) *MS*.

Colour Section: plates all originally produced as prints.

ACKNOWLEDGEMENTS

Grateful acknowledgement is made to the following for permission to reprint extracts in this book:

Dr. Rachael Whear, Mrs. Prue Rowe-Evans and Solo Syndication/The Low Estate for permission to reprint 'The Clown in White Gloves'; The Victoria and Albert Museum for permission to reprint 'The Annual Emigration of Birds'; Cambridge University Press for permission to reprint 'Cruikshank and the Grotesque'; John Fowles and Princeton University Press for 'Remembering Cruikshank'; Sir Sacheverell Sitwell and B.T. Batsford Ltd for 'The Other Genius of English Caricature'.

Whilst all reasonable attempts have been made to contact the original copyright holders, the Publishers would be happy to hear from those they have been unable to trace, and due acknowledgement will be made in future editions.